WILLEM DE KOONING

Reflections in the Studio

WILLEM DE KOONING

Reflections in the Studio

EDVARD LIEBER

Harry N. Abrams, Inc., Publishers

EDITOR: BARBARA BURN
DESIGNER: RAYMOND P. HOOPER

Library of Congress Cataloging-in-Publication Data

Lieber, Edvard.
 Willem de Kooning: reflections in the studio / Edvard Lieber.
 p. cm.
 Includes bibliographical references.
 ISBN 0–8109–4560–6 (hc)
 1. De Kooning, Willem, 1904—Anecdotes. 2. De Kooning, Willem, 1904—Friends
and associates—Anecdotes. 3. De Kooning, Willem, 1904—Pictorial works. 4.
Artists—United States—Biography. I. De Kooning, Willem, 1904– II. Title.

N6537.D43 L53 2000
709'.2—dc21
[B] 99–56282

Published in 2000 by Harry N. Abrams, Incorporated, New York

Printed and bound in Japan

Harry N. Abrams, Inc.
100 Fifth Avenue
New York, N.Y. 10011
www.abramsbooks.com

CONTENTS

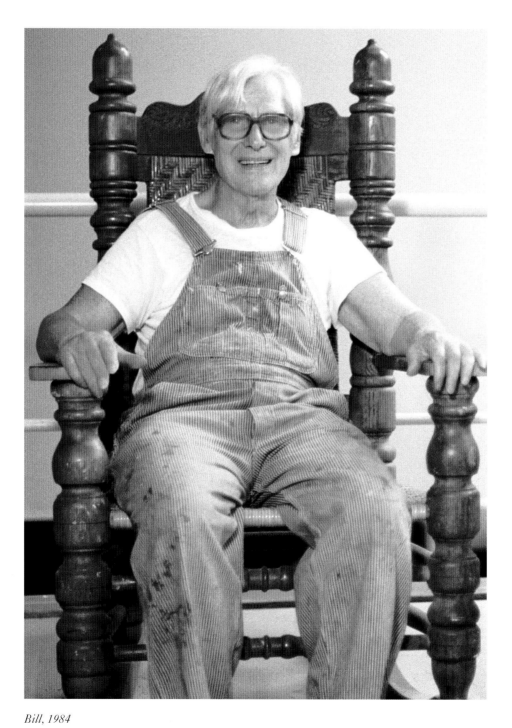

Bill, 1984

PREFACE

Music, in a sense, illuminated my first view of a de Kooning painting. From a theory class at a music school in New York, I wandered into the Knoedler Gallery in 1967 and experienced an allusive afternoon with de Kooning's singing women.[1] Perceiving art as correlative, I glanced at a canvas and thought, "*That's* legato." During the next decade, I gave concerts, turned to painting, worked as cinematographer on several European films, and sketched *24 de Kooning Preludes* for piano, inspired by his paintings. On September 6, 1978, I premiered the music at Lincoln Center.

A few months later, I was introduced to Bill and Elaine and in early summer drove out to Bill's studio for the first time.[2] The trees were in high leaf as he and Elaine welcomed me in the studio sunlight, surrounded by shimmering paintings and three blond dogs. We dined at a nearby restaurant that evening in an atmosphere of intimacy, and the past was vivid in our conversation.[3] I soon became a frequent guest.

At the opening of Bill's 1981 exhibition in East Hampton, I performed my *24 de Kooning Preludes* with a slide projection of the corresponding paintings.[4] Afterward, as I emerged from backstage, I saw two figures standing alone in the dimmed, empty hall. It was Bill and Elaine; everyone else had exited to the reception in the galleries, but they had waited for me. As we walked out together, Bill crooned with a contagious smile, "Thank you for the music."

Bill and Elaine in Bill's front yard, 1984

H.R.H. Prince Claus of the Netherlands, Queen Beatrix of the Netherlands,
Bill, Elaine, and Lisa de Kooning, New York, April 25, 1982

In those years, I occasionally photographed Bill and took some of the images on tour with me to universities and museums, where I lectured in conjunction with my concerts. When I produced my first independent film, *Seven Portraits*, I filmed him contemplating a recent painting and recorded his breathing in the rhythm of the sea.[5] A few weeks later, Elaine remarked during one of our conversations, "I wonder if you would like to come out and help organize some things in my studio." After a dizzying day of work, she and I drove to Bill's studio, where I dined with them and visited until late in the evening. In what became a fond ritual for many years, they accompanied me to the door, stepped outside under the stars, lingered awhile, and said good night.

Our evenings began to include reminiscing about their past when, in 1983, I proposed making a film about Elaine. She and Bill were receptive to the idea, and I researched attentively, as they corrected stories and recalled details that added new insight into their lives and work. They both seemed stimulated by questions, and occasionally Elaine jotted notes in her journals as we sat around the television in the evenings at Bill's. In the following months, I compiled a collection of anecdotes and a film synopsis. The anecdotes, as they appear in this book, went through many revisions, and although I was unsuccessful in raising the funding for a film, I added to them periodically.

By 1986 I was working at Elaine's studio several days a week, and we were in daily contact by telephone. In addition to her artistic activities, I helped coordinate Bill's correspondence, the storage of consignments from his gallery, and an inventory of paintings in his studio. Often, amid copious demands, Bill and Elaine's sense of humor rendered an ordinary moment indelible, as they balanced tireless work with studio gatherings, festive outings, and amusing dinners.

Elaine's studio, 1983

Elaine and Bill, 1984

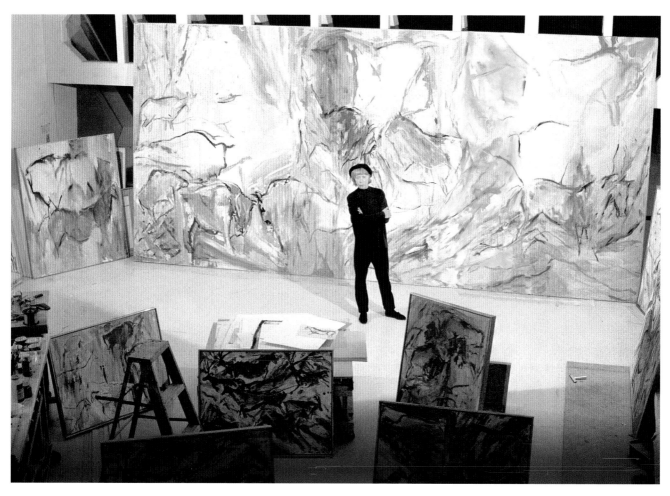

Elaine in her studio, last photograph, November 1, 1988

Suddenly, in November of 1988, Elaine was diagnosed with lung cancer. My relationship with her grew more poignant during the next three months, and when she died on February 1, 1989, I gently closed her eyes. Under Lee Eastman's guidance, I continued to visit Bill and handle his correspondence until conservators were appointed later that year.[6] As with much in their lives, Bill and Elaine had an intrepid way with words, having once described their friendships as "instant intimacy." In that spirit of conviviality, I refer to them by their first names, affording the reader a glimpse of some of the hours they shared with me.

ANECDOTES

1907

Bill's strong-willed mother repeatedly snatched him from the streets of Rotterdam when he was a small child.[7] His parents were divorced when he was three years old, and although his mother was awarded custody of Bill and his sister, his father ignored the courts and took the boy to live in his house. Calling in her "Sunday voice," his mother would search for him in the morning when he was out playing, then quickly grab him and carry him away. This happened with such frequency, that after two years, his father acquiesced and allowed Bill to live with his mother.

1910

Several children kicked over Bill's wooden cart while playing marbles with him, and some of his marbles rolled out of the cart into a sewer.[8] When he tried to retrieve them, the children removed the heavy grate and lowered him down, pretending to help him; but once he was in, they pushed him into the water, replaced the grate, and ran away. The childhood prank soon became a traumatic experience: Bill was soaking wet up to his chest and thought he was going to drown. Shivering with chills, he jumped up through the water and tried to free the grate, but it wouldn't budge. An old woman, who had been watching from across the street, suddenly appeared, silhouetted against the sky. Using a heavy stick, she dislodged the grate and rescued him, but he was left with a lifetime fear of immersion in water. Although he lived near the sea most of his life, he never learned how to swim.

1914

A cross-eyed man was repairing a house in a nearby neighborhood, and Bill sat on a stoop across the street studying him. He began to imitate the man's facial expressions and discovered that when he shifted eye positions, his vision changed, altering his perception of space. The man saw Bill making faces and became enraged, assuming he was being made fun of. He jumped down from a ladder, bolted across the street, then vehemently threw a hammer at Bill, hitting him squarely in the back. "In Holland, children made fun of the physical infirmities of older people and he thought that's what I was doing," Bill recalled. "But I wasn't making fun of him. It hurt horribly and he may have

taught me something, but it wasn't what I was looking for."

1916

On graduation day, a grammar-school teacher told Bill's mother that he was very talented and should be sent to the Rotterdam Academy to study painting and drawing.[9] "If he's so talented at painting, he can get a job painting houses and start earning some money," his mother said resolutely. He had entered public school at the age of eight, completed six years in four, and graduated at the age of twelve. The day after he left school, his mother found him a job painting a neighbor's house. A few weeks later, his stepfather took him to the Jan and Jaap Giddings decorator firm, where he was hired to work full-time, twelve hours a day. "But it wasn't really a twelve-hour day of work," said Bill. "I'd make tea in the afternoons and they would teach me formulas for mixing paints and combining mediums. There were as many techniques as there were surfaces to work on, and there were special skills for manipulating textures and transparencies. I learned a lot about the materials, and I liked hanging around older, smarter people." After several months, his schedule was reduced to an eight-hour day and he was able to enroll in the Rotterdam Academy, where he attended evening classes until the age of seventeen.[10] By that time, he had become resentful toward his mother, because she would openly flirt with sailors in her bar yet be very strict with him at home. She wouldn't hesitate to hit him if she felt like it, and if he had spare time, she would make him wash glasses and sweep floors.

1920

One of the people who influenced Bill's artistic development was Bernard Romein, an aspiring artist with whom Bill worked on display designs at a Rotterdam department store. On several occasions, Romein took him to galleries and museums to see the work of avant-garde Dutch painters, such as Bart van der Leck, Georges Vantongerloo, Piet Mondrian, and Theo van Doesburg. About three months after getting the job, Bill left home because his mother kept confiscating his salary, leaving him with only a small weekly allowance. He never returned. For a while, he roomed with Benno Randolfi, a fellow student at the academy whose parents regarded Bill as a son. "There were so many boys at the table, they didn't mind an extra one," Bill recalled. Benno's enterprising brothers pumped balloons on street corners, repaired bicycles, and played the violin on trains. Their grandfather Giovanni had walked from Italy to Holland when he was twelve years old, tagging along with a man who had a bear; it took the three of them seven years to arrive in Rotterdam. Through the Randolfis, Bill eventually met Leo Cohan.[11]

1926

In the galley of the English freighter S.S. *Shelley*, Leo Cohan had secured work

as a cook. He owed Bill a modest sum of money and returned the favor by sneaking him aboard ship the night before its departure. "Suddenly I was a stowaway," Bill recalled, "but on the voyage to America, Leo watched out for me, making sure I had food and a place to sleep." After a few days, Bill became acquainted with the crew and helped them heave coal and clean the engine room part-time. He was intrigued by the design of the ship's engine room and enjoyed the work, although the smell of burning coal lingered in his skin for days. On the morning of August 16, they arrived in Newport News, Virginia, and Bill stole off the ship while the crew disembarked. Leo showed him a circuitous way to obtain official entry papers via Boston, and within two weeks Bill arrived in Hoboken, where there was a thriving colony of sailors and Dutch merchants. Acquainted with some of the settlers, Leo found Bill a place to live in a boardinghouse where he knew the proprietress; she was Dutch and gave Bill lodging on credit while he looked for work. Leo also obtained a house-painting job for Bill at nine dollars a day and introduced him to a man who owned a sign-painting business. While living in Hoboken, Bill was able to communicate with everyone in Dutch, but in a matter of weeks he picked up broken English.

1927

"It had more corners than any city in the world," Bill said, recalling his first impressions of New York, "and each corner had its own character—with unexpected jumps in scale. The most staggering thing was that you felt it was a city that would never be finished."

1929

Nini Diaz was a graceful tightrope walker, who performed in traveling circuses and vaudeville shows using a slack rope.[12] Bill was living in the Manhattan theater district when he met her through Bart van der Schelling, a fellow Netherlander who sang in Broadway shows. Nini had bleached blonde hair, piercing black eyes, and a tiny, perfect figure. She often referred to herself in the third person, saying "Nini wants this," "Nini feels refreshed," or "Nini is going to perambulate across the street." Each day, a glass of beer with a teaspoon of olive oil and a dash of lemon juice kept her mind and body in tip-top shape. Among her friends were many circus performers, and occasionally she brought acrobats, clowns, and lion tamers home to meet Bill. She had a catchall word, "indidious": "Nini has a headache and needs an indidious," "Nini's indidious is very unpredictable today," or "Where did Nini put her indidious?" she would say.

While living with Bill, Nini took up painting and quickly became an excellent primitive painter of still lifes. Her canvases had flawless mirrorlike surfaces, achieved by rubbing her palms over the painting at the end of each day until the brushstrokes vanished. Taking cues from the circus, she applied high-key colors in surprising juxtapositions, and John Graham was so impressed with her work that he included her in his 1942 show at McMillen Inc.[13] Bill, Arshile Gorky, Jackson Pollock, Lee Krasner, Stu-

art Davis, Picasso, and others were featured, but Nini's paintings were singled out as the best in the exhibition by a critic in *ARTnews*.[14] In the mid-thirties, she left for California with a large traveling circus and returned a year and a half later, when Bill was staying in Woodstock with Juliet Browner.[15] Nini located them and moved in. "I decided to just keep on painting and let them work it out," Bill said.

1930

On the dining room wall of Norman K. Winston's New York City residence Bill painted a mural of tall ships sailing into a harbor.[16] Over a period of months, Winston also hired him to do house painting, build bookshelves, and design furniture, which was fabricated by a cabinetmaker named Schmidt. One day Winston asked Bill to clean a Boudin that was hanging in his library.[17] Bill said that he didn't know how to clean or restore an old painting, but Winston insisted he find out. Tully Filmus, a painter friend of Bill's, gave him a formula for cleaning old-master paintings but cautioned, "Be sure of the proportions and how much to rub, until you achieve the right touch."

Bill started on the sky in an upper corner, and it cleaned beautifully, but the work proceeded slowly, so he decided he could work faster by using a large cloth in broader sweeps. Finishing the sky, he quickly cleaned across the upper portion of the trees, and the color underneath glowed. Finally, he swept the cloth over a sunny meadow with several cows in the foreground. The cows vanished. Bill gasped in disbelief; he couldn't remember how many cows there were, how big they were, or what color, much less how they were painted. In a panic, he ran to the local library to find books on Boudin. There weren't any. He then flipped through picture books and magazines for photographs of cows. The cows in the painting had seemed to be grazing nondescriptly in the meadow. "They looked realistic, but in Boudin's spare style," Bill recalled. For the next couple of days, he tried to paint the cows, but each time they looked awkward and unconvincing; Boudin had indicated them with a few masterful strokes. Bill continued drawing cows for over a week, saying, "I have to learn to think about Boudin as if I were a cow!" After several frustrating attempts, he painted a few that seemed credible. When he brought the painting back, Winston scrutinized it quietly, then marveled how the cleaning made it look like a new painting. Pleased, he remarked, "It's as though I am seeing it for the first time." Somewhere there is a Boudin with de Kooning cows.

1934

In a thick snowfall, "an enchanting balletomane" named Vera Berlin trudged up Bill's street on the way home from an evening at the Russian ballet.[18] The neighborhood was blanketed in snowflakes, deserted and dark, except for a light in one of the empty buildings. It was Bill's studio. She climbed the stairs and knocked on the door. As Bill opened it and said "Hello," clouds of vapor came out of his mouth. He had been painting in the cold, and his worn gloves had holes in the finger-

tips. Vera remarked about the chill in the studio. "Oh?" said Bill. "Here, I'll open the window, maybe it's warmer outside." It was.

1935

Before signing him onto the WPA, an investigator interviewed Bill to see if he had any means of support.[19] At the time, he was still living with Nini. When the man found out that she worked in vaudeville, he said, "Hey, your girlfriend can support you, can't she? After all, she makes money on the stage." Bill exploded, "What? I'm no gigolo! I can take care of myself!"[20] He was subsequently assigned to the easel division, and although the salary of $23.86 a week was meager, "it allowed every minute to be spent on painting."

A few months later, Bill and a group of painters were invited to work on a mural for the French Line pier with Fernand Léger, who was visiting America and had been chosen to oversee the project.[21] "Here's an internationally known painter who arrives in New York," Bill said after they met him. "We were so reverent, then all of a sudden he sticks a brush into some paint—just like we did—he makes a couple of strokes on the canvas that looked kind of dumb—like we did—and suddenly all of that old mystery vanished. We thought, well, we can do that too, so maybe American artists aren't so bad after all."

Bill would have continued on the WPA, except for a conversation he had with Burgoyne Diller, who was head of the mural division.[22] "This country is marvelous! Imagine, they pay someone who isn't even a citizen a good salary to stay home and paint all day!" Bill remarked enthusiastically. "I didn't hear what you just said," Diller replied in an alarmed voice. After approximately fifteen months, Bill left the project.

The aroma of fresh-baked bread delighted Bill each morning when he woke up in his new studio at 143 West Twenty-first Street. He was living above a bakery for twenty-eight dollars a month, but within a few days, he noticed that wherever he went, the smell of bread accompanied him. It was embedded in his clothes, and what had begun as a pleasurable experience became a perplexing nuisance. "Bread. I have nothing against it," Bill explained, "but no matter where I went, it pursued me. All that bread slowly baking below me began to fill my life, and I soon realized that my nose had turned into a bread container." In less than a year, he moved around the corner to a new studio at 156 West Twenty-second Street.[23]

1936

"Meet a starving window dresser," Bart van der Schelling said to Max Mar-

gulis, as he introduced Bill to Max one night at Stewart's cafeteria.[24] Wimpy de Reuter, another Dutchman, was with them, as was Bart's girlfriend Camille, who had acted in silent films. Everyone sat around the impromptu party, eating "hot spots," Bart's amusing way of pronouncing *hotchpotch*, as he sang show tunes with a humorous twist: "Deese Foolish Dings Remind Me of You," "Der Are Bosoms on Broadway," and "Dis Cigarette Bears der Lipstick Traces." When the cafeteria closed for the night, all of them went for a walk along Fifth Avenue. As they passed a department store, Bill looked up and said, "That window is really beautiful." Everyone peered in. Then he stepped back, glanced at them, and thought, "What am I saying?"

1937

To give himself the illusion of having a model and to experiment with odd spatial juxtapositions, Bill set up a system of two mirrors in his studio. But he soon tired of holding and adjusting mirrors while trying to paint from them. One day he asked Pit Auerbach to shoot photographs of him flexing his arm and torso muscles so he could paint from photographs.[25] When he was happy with a pose in the mirror, he asked her to take a picture. He made her promise to give him the negatives, because he didn't want them "floating around"; he thought people might consider him vain—"Huh, showing off your muscles?" Pit kept forgetting to return the film, so finally, one day Bill went up to the roof of her building, climbed down the fire escape, opened her window, stepped in, saw a desk, opened a drawer, found the negatives, and took them. The subject never came up again.

Using chicken wire for an armature, Bill constructed a studio mannequin to use as a model for his paintings. He soaked a shirt, an old pair of work pants, and a jacket in a bucket of glue, then put them on a radiator until they stiffened. While they were still pliable, he put the clothing over a wire frame with the jacket inside out and bent the armature until the mannequin assumed the pose he wanted. He named the mannequin Jo-Jo. Stray props from window display jobs also began to figure in Bill's drawings and paintings: brightly colored boxes, pillows, wooden eggs, and a blue glass decanter.[26]

Elaine first met Bill at Stewart's cafeteria on a cold autumn night.[27] She was with an artist friend and Bill was alone, engrossed in a detective magazine and drinking a cup of coffee. He was wearing a seaman's cap, a thin jacket, and brown corduroy pants; Elaine noticed "his blond hair with a greenish cast, his pale green eyes, and the freckles on his lips." After being introduced, Bill got up and bought coffee for the three of them at five cents a cup. His direct, artless manner and Dutch-accented voice "gave an erroneous impression of naïveté that was dispelled as soon as he spoke." The clatter of dishes and the smell of cafeteria food were ubiquitous, but there were few people around. They talked for a couple of hours, and when the cafeteria closed at midnight, they went to Washington Square for a while. Then Bill

invited them back to his place on Twenty-second Street.

The door opened into the middle of the studio. To the right was Bill's easel, to the left the living area. Elaine was immediately struck by the whiteness throughout, offset by a few blacks and grays, making it seem as if the colors were reserved for paintings. "Immaculate, immense and luxuriously sparse," she recalled, "the space had a sea-swept look that spoke clarity." The linoleum floor was painted battleship gray, the walls a gleaming white. Furniture, which Bill had made, was built into the floor, "amplifying the sense of being on a ship." Two chairs had been carved out of wood in Arp-like shapes with cotton-duck coverings. The bed was a white plywood box on plumbing-pipe legs; two tables of the same materials were also painted white. A tall plant with three leaves stood poised near a window. In the kitchen area were two cups, two saucers, two plates, and two glasses; in the closet, one suit. "There was nothing missing and nothing superfluous. A phonograph was the only amenity."[28]

Bill's easel was off in the distance perpendicular to huge plate-glass windows that ran the full width of the studio.[29] Tacked to the wall near the easel were some newspaper clippings, a Buster Keaton photo, a Krazy Kat cartoon, some mail, and a black-and-white reproduction of an Ingres portrait.[30] Several small abstractions stood against the wall. On the easel was a painting of a seated young man with a bald head, anonymous face, oversized eyes, and curved arms in a loose jacket. The surface of the canvas seemed brushless in a prevailing tone of hushed ocher. Elaine realized later that it wasn't a likeness of anyone, but "an amalgamation, a communal portrait of Bill's image of himself, Gorky's large brown eyes, and Edwin Denby's stance."[31] Dazed, the painted man's eyes stared past the viewer in an unfocused, hypnotic calm that seemed sightless. Bill's one remark was, "I feel that I have to keep my paintings wet for months at a time in order to keep them alive." They sat on a couch opposite the painting, listening and silently looking. On the phonograph *The Rite of Spring* was playing at full volume.

1938

Wet-on-wet was Bill's way of working, which could easily muddy his colors. To counteract that, he scraped and sanded the areas he wanted to change, revealing echoes of earlier passages. "Too antique" was Bill's observation at times, because the resulting pentimenti resembled Roman frescoes, so one of his solutions was to heighten the colors. His painting was additive and unpredictable, and the changes were often drastic, "sometimes wiping out an entire painting, leaving a mere ghost of three month's labor." Charcoal and pencil interacted with paint, colors sank into each other, and contours intertwined, sometimes through each other. In paintings of the thirties and early forties, the placement of the male figure constantly shifted; at times the face remained fixed while the position of the folds in the jacket and trousers was altered. Bill remarked, "I didn't know how to contend with hair; it always looked unnatural, and it constantly changed the weight of the head and the stance of the gaze." Pillowed shapes for hair were gradually replaced by bald heads.

Gorky was reading through a magazine in Bill's studio and said to Bill, "Those commercial artists, you have to hand it to them. They work to please someone else. We can't even please ourselves."[32]

Bill managed to get a job interview at a display company, but he had no overcoat, so Max Margulis loaned him his. For nearly two years, whenever Bill needed a coat, he would go to Max's, borrow his, wear it to a job, and then return it.

1939

"You should try painting things that are a direct part of your life, not social history or myths," Bill suggested, when Elaine began to study with him. "There is no way I can respond to what you do if you paint out of your head. But if we are both looking at the same subject in front of us in the same light, I can discuss tones and contours, spatial relationships, composition, whatever, and there will be something concrete to talk about." They decided that Elaine would come to the studio each morning and work on a still life. First, Bill discussed Cézanne's paintings and the importance of arranging cloth. In the studio he had a few army blankets, one of which he tacked up against a wall. He brought out a yellow cup, a coffee pot, and a large seashell and had Elaine arrange them in relation to the folds, explaining how to "clarify" the space around the objects. Then he stretched a canvas. "Now just start," he said, and she began to sketch the still life with charcoal, working each day toward evolving a painting.

"Wildflowers seem to cover everything," said Bill, when he first visited Elaine's family in Brooklyn on a Sunday afternoon. He was also struck by the gardens, songbirds, window boxes, butterflies, and empty fields with buildings in them that seemed abandoned or just begun. There were candy-store hangouts, roller skating, an occasional horse and wagon, and children laughing and screaming, playing ring-a-levio in the streets. Elaine remarked that it was "a place to run away from by subway." After dinner, she and Bill would walk down to Sheepshead Bay; the docks, restaurants, fishing boats, and shipyards fascinated Bill. "I'd like to live in a room over one of those stores," he said, pointing. "It reminds me of Rotterdam." They learned later that the area was originally settled by Dutch immigrants and many of the streets still had Dutch names.

Elaine arrived at Bill's studio one morning to find him rushing around, rearranging fifteen large pieces of cardboard he had painted white. He rapidly drew elegant life-size female figures on them with quick-drying black enamel. After a few hours, he scooped them up and rushed out of the loft to meet a deadline for a window-display job. A few months later, he got a *Harper's Bazaar* assignment to make pencil drawings of women's faces with assorted hairstyles. Elaine went to a five-and-ten, bought cheap hair-

pieces, and integrated them into her own hair, creating a variety of hairdos. When Bill delivered the drawings, the magazine's editor was disappointed; instead of giving them a full page each, he reduced them and ran all four in a semicircle on one page. As he paid Bill, he informed him that it would take at least five years before he would be good enough to make a living as a commercial artist. Bill was flabbergasted and thanked the editor, deciding at that moment to abandon the idea of pursuing a career as a commercial artist.[33]

Max Margulis founded Blue Note Records with Alfred Lion and Emanuel Eisenberg on March 22. Over the next several years, he invited Bill, Elaine, Ibram Lassaw, Aaron Copland, Edwin Denby, Rudy Burckhardt, and many other artist friends to jazz clubs, introduced them to musicians, and stocked their studios with the latest records.[34]

"People used to talk about the similarities between Bill's and Gorky's paintings, but by the late thirties, the differences were much more important," Elaine observed. "Gorky's way of working was direct and additive—he reiterated images, overlaying coat upon coat of paint until, sometimes after weeks, the contours were raised and the canvas physically thick with paint, engulfed in heavy impastos. Bill scooped off the paint and sanded large areas, leaving barely a skeleton of the shapes and colors, eradicating the contour edges. He kept his colors thin on the surface, often scraping the canvas at the end of the day, then sanding with turpentine the following morning before starting to paint again."

Bill stared at one of Elaine's canvases, then pointed to a section, saying, "I think you should move this two inches to the right." Elaine countered, "I think I should move it two inches to the left." Bill fired back, "You son of a bitch, you just got out of the cradle. There are things you don't know!" Elaine said, "Name four."

1940

John Graham was the first artist to post a "No Smoking" sign in his studio. Late into one of his high-spirited parties, artists began to entertain each other by performing stunts. Graham, a yoga expert, crossed his feet up behind his head and suspended himself off the floor on the palms of his hands. Elaine did a split, then placed a handkerchief by her toes and retrieved it with her teeth. Gorky sang and danced ancient Armenian songs, extending his long arms and snapping his fingers. Bill did the Russian kazakhsky and began throwing out his legs in rapid kicks. Suddenly, he doubled over in pain. A piece of cartilage had broken off and lodged inside his knee, causing it to swell to the size of a grapefruit. No one had money for an ambulance, so they rushed him in a taxi to a hospital on Welfare Island and had him admitted.[35]

The following morning, when Elaine returned to the stale-smelling ward, Bill said grimly, "They serve the worst coffee here; it's cold, three-quarters water, and just awful." The doctors had rigged him in traction with a plaster cast attached to pulleys and informed him that they would do exploratory surgery in a week, but that one leg might be shorter as a result. By now his leg was frozen in a bent position. "Being tied to the ceiling gives me vertigo, and being in a cast gives me claustrophobia," he said anxiously, "but I guess they know what they're doing." Elaine stared at him: "When you're unconvinced, you look unconvincing. Besides, if they know what they're doing, why do they call it 'exploratory'? I don't like fooling around with the knee." "I don't like fooling around with the knee either, particularly if it's my knee," said Bill.

When she arrived the next day, he wasn't in bed, nor were the other two patients who had been in the room. An hour later, the three appeared in wheelchairs. "These are Bowery bums," Bill explained. "They're nice guys, and they both got hit by cars the other night." He continued, laughing, "I told the doctors to take that metal junk off me and throw it out the window, and when these two guys saw them remove it, they said they wanted to get out of traction, too."

Elaine returned home that night to find a notice taped to the door: "Greetings. You are hereby ordered to vacate the premises for non-payment of rent." The electricity had been cut off two days earlier. As she walked in numbly and sat down in the darkness, she groped for the remains of a small candle to provide a flicker of light. Suddenly there was a knock at the door, accompanied by Gorky's "sepulchral voice, as though from the bottom of a tomb." She opened the door and told Gorky about Bill's plight, that they wanted to operate, that Bill might wind up with one leg shorter than the other, and they were going to be evicted because they had no money. After a heavy silence, Gorky nodded, then mimicked Bill limping pathetically down the street, saying, "This is nice, something new, yes—very nice." They both burst out laughing and decided to get Bill out of the hospital immediately. Within a few weeks, his knee healed perfectly.

In the early forties, there were many industrial lofts available in the city, and because of their enormous scale, they quickly became the most desirable studios. Lofts with skylights were particularly sought after; without them, daylight was interrupted by adjacent buildings. Most lofts had no central heating, and artists had to resort to kerosene stoves; the canisters had to be refilled at a hardware store, sometimes as often as once a week in the winter. Cleaning the stoves was supposed to be done every few weeks but was usually done every two or three months. A heavy buildup of soot had to be attended to, because it could easily catch fire. It was scraped off the walls inside the stove with a palette knife or spatula, but no matter how careful one was, it was a messy job: the soot would leave oily streaks on one's hands, clothing, and floor. When kerosene ran out, the main source of heat was the cooking stove: its burners and oven were frequently left on during the night to heat the loft in cold weather.

At first there were no refrigerators. In winter, food was stored outside the windows or on the fire escape, and in summer, just enough food for one meal was kept indoors. Gas and electric meters were often switched around to prevent them from registering the amounts used. Artists warned each other when meter men were making their rounds, and they mastered repositioning the meters at a moment's notice. There was no public garbage pickup, so artists had to carry their rubbish down in paper bags and drop it in trash cans on street corners; this was illegal, but no one knew what else to do with it. Originally, none of the lofts had showers or bathtubs. However, since most of them had been sweatshops, they had two separate toilets, one for men and one for women; the plumbing in the second one was easily converted into a shower. Almost everyone had a radio, but no one owned a vacuum cleaner, washing machine, or telephone.

"We never considered ourselves poor, just broke," Elaine remarked, "and even in the mid-forties success did not loom as a possibility. New pictures were often painted on top of old ones because there was no blank canvas in the studio. Consolidated Edison was the key patron, as a lot of artists became expert at jumping gas and electric meters to keep warm and to have light. We often thought of the lifestyles of Soutine, Modigliani, and van Gogh, but artists who were successful in their lifetime—Gainsborough and Sargent—were 'lightweight' and 'fashionable,' terms of opprobrium. As the decade progressed, abstract painters were less constrained, less inhibited, less ultra-neat, and they became more involved in American art rather than European art."

At the Automat, a group of artists were discussing Edwin Denby's ballet criticism. "Instead of Edwin writing about Markova's dancing, Markova should dance about Edwin's writing," said Bill. Every so often, Edwin would bring his friends a newly completed poem, the way painters would show each other a new painting. "He was the only person we met," Elaine recalled, "who imposed his own time through the light he cast—pale, transparent, and bluish—strictly moonlight, even in noonday sun."

Vera Berlin's brother worked for impresario Sol Hurok, and she persuaded him to commission artists in America the way Diaghilev had in Russia. The artists were invited to make sketches for ballet sets and have them exhibited in a one-week show, organized with the help of Kirk Askew at the Durlacher Bros. Gallery. Vera brought Léonide Massine to the opening, and he selected Bill to do the sets for *Les Nuages*, a ballet choreographed and danced by Nine Theilade.[36] It was to be premiered by the Ballet Russe de Monte Carlo at the Metropolitan Opera House on April 9.

Massine introduced Bill to Mme. Karinska, a costume designer from czarist Russia, who immediately decided that Bill should come to live in her house. "You shall have studio and all meals for you and place to sleep. Time to time you will design costumes for me," she decreed imperiously. She had a Chi-

nese butler named Ming, who ordered everyone around, including her. As far as Karinska was concerned, Elaine was invisible; she never invited Elaine to her house and never spoke to her.

When Bill declined Karinska's offer to move in, she instantly issued orders for costumes: "Single clouds! Groups of clouds! Night! Dawn!" Within a few days, Bill brought her several sketches, but she was puzzled as to how they were to be executed, so she insisted he provide sewing patterns for each costume. Bill contacted Lon Ross, a designer he had met at a display company, and Ross made the patterns. The "clouds" wore intricate layers of chiffon, with an occasional feathery bird perched on a shoulder; their wings fluttered delicately as the ballerinas danced. "Dawn" was in pink and turquoise tights, with white flowers cascading down her luminous blond hair. "Day," symbolized by the sun, danced intermittently in a multicolored jumpsuit speckled with dabs of bright sparkling paint. "Twilight" appeared as two women in gray, airy gowns with pale lavender flowing hats. "Night" had deep-blue veils with stars that trailed airborne as she floated across the stage. The costumes were being dyed on the day of the premiere, and the dancers were still waving them over radiators a few hours before curtain time. "On opening night, everyone treated me with enthusiasm and respect," said Bill. "Then all of a sudden, they acted as if they'd never seen me before." After mixed opening-night reviews, Karinska complained that the costumes were visually distracting, so she ordered the dancers to snub Bill on cue.

"At the time, there weren't any geniuses staring us in the face when we walked out of our studios," Elaine said. "We didn't see Michelangelo crossing the street, Rembrandt waiting at a light, or Rubens passing by in a taxi on his way uptown. Although we were in awe of the old masters, we didn't inherit their kind of tradition, and it wasn't imposed on us to build on them. That set us free. There were no galleries, curators, critics, or collectors; in fact, American galleries and collectors did us a service by ignoring us. They scooped up the treasures of Europe to satisfy their own tastes and dumped Picassos, Matisses, Mondrians, Kandinskys, and Klees into our visual laps. We were our own audience, our own critics, and we painted for each other."

While visiting the Metropolitan Museum one afternoon, Bill and Gorky studied the Pompeian frescoes and then approached a room filled with Greek statuary. There was no one in the room except a young girl. As they looked in, she walked up to a marble statue of a Greek athlete, spontaneously kissed it on the cheek, and ran out. After a few moments' silence, Gorky whispered, "Ah, the seduction of antiquity!"

1941

Plump and outfitted in tight clothes, Pierre Lafitte dyed his hair black and lived in a palatial duplex without furniture at the Gainsborough Studios overlooking Central Park. A

connoisseur of redheads, orchids, and champagne, he claimed to have descended from a Louisiana pirate, and he found painting commissions for Bill. "I feel like an artist and live like one, an artist in soul if not in body, but I have the wrong hands and no talent," he confided to Bill. "That's why you need me," he continued, tapping Bill on the shoulder. "I need you?" Bill asked incredulously. "Yes, because I can get work for you. You can do the work, but you can't get the work. You say you want to do commercial art to make money; I have all the contacts you need and I know all the designers. The way it will go is this. I can convince anyone that I'm a great painter. I'll find the jobs and you'll do them. I'll sign them and there will be plenty of money for both of us; we'll split it fifty-fifty, and you"—he pointed at Bill as though he were a conductor signaling the first violin—"you will draw and you will paint." Bill was skeptical but willing to try.

Their first collaboration was a pipe-tobacco advertisement. "Draw a kindly old man smoking a pipe," Pierre instructed. "Very cheerful, yes, he's a sea captain and he's winking. No jacket, just a shirt and cap, and put overalls on him." The next morning the drawing was finished. "I think we should have a background, maybe a seaport with a church." Bill drew them. "And maybe a ship sailing in the distance with one seagull." Finally, Pierre was satisfied. "Now I will sign it," he said, running off with the drawing. That afternoon he came back with two hundred dollars. "Here's your share, a hundred for you and a hundred for me—and I have another job. You're in a car, your hands are at the wheel, you see the road through the windshield—nice vista, sunny day, one cloud, a hill in the distance, birds flying—now draw it." He snapped his fingers in a sweeping gesture, "and make it look as if you're going a hundred miles an hour." Bill spent as much time on jobs for Pierre as he did on his own paintings. Pierre would take a drawing, sign "Pierre Lafitte," get paid for it, and give Bill fifty percent.

Within a few months, Pierre was offered five hundred dollars to paint the portrait of a Tammany Hall judge. "Make it life-size," he told Bill when he arrived with a black-and-white photograph, "but do it in color." Bill said he had to see the judge in order to render the color. Pierre made an appointment, and when they arrived, Bill was introduced as the photographer. (Bill told Pierre he didn't know anything about photography, so Pierre arranged to have a real photographer go along as Bill's assistant.) "I will explain that you select the pose, but because you are so important, your assistant takes the picture," Pierre told Bill. "Have him put both hands on his desk," Bill whispered to Pierre. "Look stern—as though you're sentencing Al Capone!" Pierre commanded. The judge pulled his face together in a knot as Bill moved the photographer around to take photographs from different angles. Pierre announced that he had to think about the portrait and would return with a sketch in a week. The photographer printed the photographs, gave them to Bill, and the portrait was begun. About three weeks later, Bill said that he had to look at the judge one more time to check the colors. They returned with the canvas, being careful not to let the judge see it. "Don't move," Pierre warned the judge, while elaborately squeezing paint onto the palette according to Bill's instructions. Pierre could dab oil on the canvas, but

he was not to go over any of the painted areas. With great flourishes, he dipped the brush onto the palette and made sweeping gestures, stepping back and forth theatrically. Meanwhile, Bill made surreptitious sketches with pastels on paper. After two hours, the fat, bald judge looked at the canvas and was enthralled. Pierre said he would now be able to complete the portrait from memory in his studio. Bill finished the portrait, then he rehearsed with Pierre how they would unveil it and how Pierre should sign it in front of the judge. When the judge saw the painting, he praised Pierre effusively, declaring him a genius.

Bill cleaned his studio weekly, a job that took more than half a day. Elaine helped him one day and he said, "I wish I could just hose it down."

While strolling up First Avenue on a bright summer morning, Bill and Elaine heard Renaissance choral music coming from a church. They wandered inside and sat down. A funeral service was in progress, and incense billowed through the somber air as someone delivered an oration. Within minutes Bill and Elaine began to cry. When the eulogist sat down, a mourner in front of them turned around and sympathetically offered a handkerchief, saying, "Did you know him well?" Bill replied, "We didn't know him at all, did you?" The woman let out a sudden gasp and ordered them to leave the church. "Get out! Get out immediately!" she whispered hoarsely. "I forbid you to remain here another second! Disrespecting the dead!" Back out on the street, Bill said casually, "Come to think of it, when I die, I don't want my body referred to as 'the remains.'"

1942

"Your chin is dropping. Lift your chin. No, stop—not that much!" Bill walked over and put his hands on Elaine's back. "Lower your shoulders. Now put your elbow this way. Turn your left hand in a little more. There, now you look relaxed," he said earnestly, squinting his eyes. "But I'm extremely uncomfortable," Elaine murmured. "This position is awkward and strained. I can't look at ease like this." A pigeon landed on the windowsill next to where Elaine was sitting and began to coo. "Now you're looking at the bird!" Bill growled, as he approached the window and banged on it to chase the pigeon away. "Here, turn this. Now raise—no, lower your right forearm, move your head a little to the left of the shoulder." Elaine began to laugh. "Giggling like a schoolgirl," Bill commented, as he returned to his easel and drew, his eyes darting back and forth at a rapid rate from the paper to Elaine's face. "Your eyes are focused too far behind me. You're looking through me," he asserted. "I want to draw your eyes focused on me; look directly at my eyes." Elaine giggled again. "I am looking at your eyes but you look so furious that it makes me laugh. I'll calm down in a minute. You look so angry and I don't deserve it, and it makes me laugh to see you like that." "Well, just hold it like that," he said, "and don't

breathe."[37]

Gorky never read art criticism. "Would you decide what tastes good based on the words of a food critic in the newspaper?" he asked.

Cafeterias and Automats were a vital part of the intellectual life of the city.[38] The Automats had good food, but small portions; cafeterias had glop, but large portions. Each place had its own crowd of artists who were habitués, and Elaine and Bill frequented Stewart's cafeteria, which was open until midnight and full of friends; the spontaneity of their meetings was part of the fun. A counterman at Stewart's who doubled as cashier bought paintings and drawings on the installment plan, allocating two dollars a week to his purchases. He was sympathetic to the plight of artists and frequently gave them double portions on the sly. Most of the artists were unmarried, living in a spirit of extreme frugality, and on the WPA. Married artists visited the cafeterias at night without their wives, who were home asleep because they had to get up the next day to go to work. With rationing and food stamps, cups and sugar bowls began turning up in artists' studios, crucial for their daily coffee.

1943

"I have a heart condition—I'm a sick man. I need the money!" pleaded Mr. Finkelstein, Bill's landlord at 156 West Twenty-second Street. Each month he would pound on the door and yell out that he had to have the rent money, but Bill and Elaine would ignore him and hide, because they felt it was pointless to discuss the subject. One month Mr. Finkelstein surprised them by climbing up their fire escape. He began to bang on the window. "I see you, I can see you!" he shouted through the glass, as Bill and Elaine tried to elude him. "Please, let me in!" Elaine lifted up the window. "Just in time for a fresh cup of coffee," she announced, pointing to the stove. Putting down her paint brush, she helped Mr. Finkelstein as he struggled to squeeze through the window. When he freed himself and stepped into the loft, she added, "Did anyone ever tell you that you look like Ingres's portrait of Monsieur Bertin?" They spent a friendly hour chatting, but when the landlord left, he did so empty-handed.

That autumn the tenants who lived on the floor above told Bill they were going to move out. Their loft had a higher ceiling and a huge skylight, so Elaine decided to approach Mr. Finkelstein about moving one flight up. She made an appointment and went to visit him in his office. "Mr. Finkelstein," she began. "Boyce," he interrupted. "I beg your pardon?" Elaine said, puzzled. "Boyce. The name now is Boyce. Byron Boyce," he replied. "Mr. Boyce," she said, "Bill and I are going to get married and we want to cut down on expenses, so we thought we would move to the top floor, which is much less desirable because it's a flight higher and it has that infernal light pouring through the skylight all day long, so it should be ten dollars less a month. However," she continued, "we're willing to pay the same rent we're

paying now, but maybe you could forget the three months we owe you." "One moment, please," said Mr. Boyce, "I want my lawyer to hear this." He pressed a button on his desk and said, "Jerry, will you come in here for a moment?" A lawyer appeared. "Now, will you please repeat your offer to me?" he asked Elaine. When she finished, the lawyer rolled his eyes, then Mr. Boyce carefully withdrew a twenty-dollar bill from his leather wallet and offered it to her. She looked at him inquisitively and slowly reached out her hand. He snatched the money away, exclaiming, "See? She'd take it, she'd really take it—my hard-earned money!" Tapping his fingers on the desk, he leaned forward after a few moments and said, "The rent will remain the same. You're lucky I don't raise it." He then looked affectionately at Elaine, put his hand out, and said, "Good luck to the two of you."

A few weeks later, Bill began to renovate the new loft. He installed a kitchen and bath, put down linoleum (which he painted light medium gray), then painted the walls and ceiling a bright white. They both worked on the design for the bedroom: situated in the middle of the loft, it had six-foot-high walls open to the ceiling, painted white outside and pink inside. There were two windows, one facing the kitchen and one facing the studio, and the walls were double-thick with a door "in case Elaine didn't make the bed." Small pink tables stood on either side of the bed, and there was a pink closet for Elaine's burgeoning collection of ragged blouses and run-down shoes.

Bill's easel was perpendicular to the windows facing the street; Elaine's "studio" was a space enclosed by three-foot-high bookshelves under the skylight adjacent to the bedroom. Each evening, when Elaine arrived home from working at Liquidometer, Bill was tirelessly building shelves and partitions, though often in a grumpy mood, because the months of carpentry kept him from painting.[39] But since Elaine's salary was paying for the cost of materials and she wasn't painting either, they commiserated with tales of the day's happenings. The studio was dusty and forlorn, full of wallboards, lumber, tools, buckets of paint, and bags of nails, "all contributing to a depressing atmosphere to sleep in." One day, when she arrived home from work, Bill surprised Elaine with a new shower. "Where did you learn plumbing?" she asked, astonished. "It's self-evident, but those fixtures are complicated," replied Bill. "I went to the hardware store and told them what I wanted to do, so they filled a box with a bunch of parts and when I came back here and laid them out on the floor, everything fit together."

The building was sold a few months later. Mr. Boyce confided regretfully, "The people who are buying this building—they're going to use your floor for storage and they want you out." By that time, Elaine and Bill owed five months' rent, so they resigned themselves to losing the skylight loft. They went out studio hunting and found "a fifth-floor walk-up with hot water and no heat for eighteen dollars a month at 63 Carmine Street" and "a dismal studio space facing the back of Grace Church for thirty-five dollars a month at 85 Fourth Avenue."[40] Having two places meant they could have separate studios. The combined rent wasn't much more than the rent for the lost loft, and more importantly, neither place needed renovations. They decided to live at the Carmine Street flat, which doubled as

Elaine's studio. It had a porcelain bathtub in the kitchen, and when they had no money for kerosene, the gas stove served as the heater. The "large" room was ten by fifteen feet and provided a northern view through two windows overlooking Seventh Avenue. Bill installed a three-by-six-foot mirror perpendicular to the windows, which enhanced the light and created a double view of the city.

Gorky often took Elaine and Bill to Arpenik, an Armenian restaurant on Twenty-seventh Street that offered hearty soups and savory stews for fifty cents a serving. The jukebox played enchanting Armenian music, and an Armenian woman was the proprietor. After dinner, Gorky would don his jacket in reverse (revealing its bright silk lining), drape a scarf around his shoulders, and tuck his pants into his socks, transforming himself into a strapping peasant. The waiters would clear an area of the floor, and Gorky would teach everyone folk dances he had learned in childhood, rousing the patrons to sing and dance until late in the evening, when the restaurant closed.

Lever Brothers wanted Bill to do an advertising campaign. "But I can't paint or draw about soap," he said to the representative. "You don't understand. Do you know how powerful we are?" the man replied. Bill turned the job down.

A group of artists at the Waldorf cafeteria were arguing fiercely about reports of Hitler and the Germans. Bill became irritated and interjected, "You're being cubistic about morality. If they could do it, we could do it too—just look at all of you with your mouths full of food, while you talk about millions starving to death in concentration camps."

"Something old"—Elaine's wedding gown, a simple navy blue dress that was four years old. "Something new"—the wedding ring, a plain gold band that Bill bought for $9.50. "Something borrowed"— her sister Marjorie's leather handbag. "Something blue"—a necklace of thin glass beads. Their wedding was on Thursday morning, December 9. "Unhampered by sanity," Elaine's mother refused to attend, declaring that none of her children should marry for the next ten years. "And don't forget," she vowed, "it breaks the Second Commandment."[41] Elaine's brother Peter, her sister Marjorie, and their father attended, as did Bill's friends, Bart van der Schelling (as a witness), Daniel Brustlein, a cartoonist for *The New Yorker* (as a second witness), and Max Margulis (as best man).[42]

Everyone met that morning at Elaine and Bill's loft and drove down to City Hall in two taxis. During the ceremony, Bill kept saying "I do" to each phrase: "to have," "to hold," "in sickness." Suddenly the justice of the peace peered at Bill with a reprimanding glance and ordered him to remain silent. When the justice carefully finished reciting his part, he looked testily at Bill and demanded, "Well, do you?!" Bill looked around and said, "Sure!" Everyone giggled. Then he added with a smile, "And that's

the last time I'll ever take an oath!" After the ceremony, Elaine's father took them to a nearby bar for a drink and a bite to eat and then returned to work. Everyone else went home. That evening, Bill and Elaine were invited to Howard and Charlotte Bay's apartment for dinner; he was a stage designer friend of Nini's. The Bays gave them their only wedding gift, a box of large, heavy, pea-green dishes.

1944

A few weeks after they were married, Bill and Elaine managed to have a telephone installed. "For the first week, it was amusing to call the few friends who also had telephones and to receive calls from them," Elaine said. "However, after a month, it began to ring persistently and the sound became irritating, like an angry dog barking all day long." Bill got so fed up with the interruptions that he ripped the phone out of the wall one day while painting.

To economize, Elaine decided to cook at home; they both thought it would be cheaper than eating out at the Automat or the cafeterias. A friend gave her a cookbook of standard recipes from which Elaine selected "Beef Stew—Serves 8. A pinch of this, a pinch of that." But Elaine didn't have the basic ingredients and spices in the house, so the pinches cost fifteen dollars. The "Beef Stew—Serves 8" took a day to make and was devoured by the two of them in five minutes at a cost of over twenty dollars. They realized they could have eaten out two or three nights in a row for the same amount of money, without having to shop, prepare, cook, or wash dishes.

Late one evening in a thick fog, Bill and Elaine walked along Battery Park. Muffled horns from barges looming up and down the Hudson River echoed in the damp air. Bill said to Elaine, "I'd hate to be a fish, eyes always open, never lies down, always cold and wet."

1945

There was a sudden pounding on the door. Bill approached it and said, "Who's that bouncing at my door?" A voice answered, "Con Ed!" Bill replied, "That's all I wanted to know," and walked away. The man continued to bang on the door, then finally gave up. He reappeared the next morning and shouted through the door, "I represent Con Ed! Open up immediately!" After a pause, he blared, "I've got a subpoena for you!" Bill opened the door furtively. Papers were thrust at him, as the man asserted, "You're de Kooning—take this!" Bill replied calmly, "I'm not de Kooning, I just work for him." The stranger looked unconvinced. Bill added emphatically, "If I go to the Con Ed building and say, 'Con Ed!!' to you, you don't think I think you're Mr. Edison, do you?" The man went away.

"A kiss," Edgard Varèse demonstrated, "is a good raw sound. Listen. Wnuoip. Wniuiup. Wnoiiupp! And

if you project the upper lip beyond the lower—Wmnniiiuupp!!" Varèse had invited Elaine and Bill to sample his collection of noises and sound effects, accumulated over many months.[43] "Now, you try," he proposed, as he adjusted the knobs on his tape machine. Elaine and Bill blew kisses into a large microphone. Elaine made ones that were "forbidding and flippant," while Bill's kisses were "taut, barely discernable, yet playful." Within minutes, Varèse altered each of them, transforming them into massive rhythms, haunting textures, and stark motifs.

People began to knock at Bill's door every day and shout out their names in order to be let in. There were only three chairs in the studio, one of which was Bill's, so most of the visitors had to sit on the floor. Bill would converse with them while his eyes remained locked on his painting, and every so often he would walk up to the canvas and quietly add a few strokes. When he was alone, however, if his painting wasn't going well, he would storm up and down the studio, bang his worktable, knock over a chair, throw brushes at the wall, or curse and kick his paintings, sometimes puncturing them.

1946

Marie Marchowsky, a former student of Martha Graham, was premiering her new ballet, *Labyrinth*, at New York Times Hall on April 5. Edwin Denby introduced her to Bill, and she commissioned him to do a backdrop for fifty dollars.[44] Because there wasn't much time, Bill took an existing work on paper, squared it off using tracing paper, had cotton duck sewn together to make a large panel, and painted the backdrop with the help of Milton Resnick.[45] Using calcimine paint as a base, Bill added traces of oil pigment to heighten the color, and he and Milton worked on the seventeen-foot-square canvas for nearly a month.

"Do you like ice cream?" Edgard Varèse asked Elaine. "I love it" she replied. "Good. I will take you to have wonderful ice cream," he said. They went to Greenwich Village and ate gelati in a place "where only men sat." "The pistachio ice cream here is mouthwatering; its texture is to be found nowhere else," he declared as they entered. After they finished, he said, "Now I will take you where they have irresistible fresh strawberry ice cream." They went to six different ice cream parlors that night, each with a specialty ice cream that Varèse was privy to. At every parlor Varèse espoused the qualities of each flavor, imbuing them with the textures and harmonies in French music.

On many occasions, Bill invited friends over to sit and listen to classical music for hours without talking. *The Magic Flute* was one of the recordings Max Margulis had given him, and he listened to it repeatedly on his phonograph. Eventually, he was able to whistle the "Queen of the Night" aria from memory, hitting each high note flawlessly and in tempo.[46]

Harold Rosenberg stood up before curtain time at a Cage/Cunningham performance and announced in a booming voice, "There's a stranger in the third row—throw him out!"[47] John and Merce's audience was "built-in," consisting of dancers, painters, sculptors, and writers, all of whom were acquaintances or close friends. As the lights began to dim, Harold jumped up again, glanced around, and protested, "The evening can't start—the Lassaws aren't here yet!"

Elaine was rushing around the studio one morning, and Bill asked her why she was in such a hurry. "I've got a deadline," she quipped. Bill replied, "Don't mention death in the house."

1947

A man arrived at Bill's studio with a photograph of his wife and an armful of pornographic magazines of women. "I'll pay you fifty dollars in cash to make a painting of this here body with my wife's head on it." Bill declined the offer.

At a party Elaine and Bill met some friends who were going abroad for a few weeks. The next morning Bill said to Elaine, "How can those people afford to go to Europe? We can't even afford to stay here."

1948

Visibly drunk, Jackson Pollock lurched up to Gorky at a party and began making contemptuous remarks about his paintings.[48] "Gorky, they're just weak . . . ," he whined. Gorky paused a moment and then, with a lethal smile, reached slowly into his coat pocket, pulled out a large knife, and carefully opened it. He removed a pencil from another pocket and began to sharpen it with the precision of a Zen master, all the while keeping his eyes fastened on Jackson's face. Hypnotized, Jackson and everyone in the room watched in silence as the tip of the pencil came to a surgically sharp needle point, in what seemed a symbolic ritual. Gorky took a deep breath and blew solemnly on the point, which instantly shined. "Mr. Pollock," he cooed with mock affection, "you and I are different kinds of artists."[49]

Charles Egan was a dealer who enchanted everyone with his mixture of reverence and merriment.[50] He collected surplus vitamins from doctors and distributed them to artists, urging them to take the supplements with their morning coffee. In 1946 he approached Bill about having a show in his gallery at 63 East Fifty-seventh Street.[51] Bill preferred Egan because most of the other galleries were established, and Bill didn't want to have "a reputation based on a gallery's reputation." "Collectors are beginning to collect dealers rather than artists," he noted. Elaine conferred with Charlie, "As you know, Bill has a reputation for never finishing a painting, and the only way he will have enough paintings for a show is to

commit him to a date. He never misses a deadline." Charlie decided, "Okay, it's September 1946. How about April 1948—that will give him a year and a half." Bill agreed to the date. He was already working on paper that was sized, in order to withstand the sanding and scraping that was still part of his technique for evolving a painting.

A year later, Bill was apprehensive about not having enough work for a solo show. He kept insisting, "Your first one-man show can't look like a mini-retrospective; it has to be one state of mind and have a unity of style." Black and white was one way of insuring that, and by March 1948 he finished the paintings and stripped them. A few days before they were delivered, Bill, Elaine, and Charlie got together at the Carmine Street flat and named them, with the stipulation that any title had to have three votes.

There was no opening reception, and Bill didn't go to the gallery on the first day of the show. He stopped by a few days later, and again toward the end of April when he returned to have another look. Nothing had sold. As he stepped into the elevator, the elevator man looked at him reprovingly. "Here it is three o'clock in the afternoon and you're bumming around," he said irately. "Don't you have a job?" "Yes," Bill professed. "I'm a manual laborer—I work the night shift." Egan extended the show through the month of May and again through June because of lack of sales.

Josef Albers decided to offer Bill a teaching position at Black Mountain College after seeing his paintings reproduced in February's *Magazine of Art* and April's *ARTnews*.[52] The salary was two hundred dollars for the whole summer, plus room, board, and two round-trip train fares. Elaine and Bill left New York for Asheville, North Carolina, in a heavy rainstorm, traveling "in a bleak overnight train that was full of soldiers who slept on the floor." Coarse pieces of lumber had been used to repair the rattling seats, and the jutting edges snagged their clothes throughout the journey. They were unable to sleep because rented pillows were fifty cents apiece—"a prohibitive luxury"—so they read mystery magazines and talked all night.

A bright, perky student met them at the train station the next morning, but when they arrived at the college, their immediate impression was one of indolence: listless students were yawning everywhere, lying around in the humid heat. The cabins were small, shabby, and not much larger than an ordinary bathroom. Bill decided to paint in the "large" room of their cabin; Elaine chose the tiny room with a view of the lake. Albers greeted them at noon and took them on a brisk tour of the campus. In the midst of their stroll, a feeble tin bell rang, eliciting a sudden stampede toward the cafeteria for lunch. Albers nodded at the running students and scoffed, "Pavlov's dogs!"

Within a few days, they met John Cage, Merce Cunningham, Ray Johnson, Rudy Burckhardt, Buckminster Fuller, Arthur Penn, and many of the other faculty and students.[53] An atmosphere of spontaneous combustion took over the college as the divergent talents interacted. Everyone was required to take Albers's classes. One of his fundamental principles was that art could be fashioned from any mate-

rial, such as a ham sandwich or an umbrella; the directive was to use the colors and forms of an object in an assignment. Merce's classes were held in the dining room for two hours each morning, six days a week; "run full speed and suddenly stop" was one of his introductory exercises. Fuller's classes included several students who had traveled from Harvard to study with him; his concept of architecture was based on mechanics using models and paper cutouts rather than aesthetic theories. John Cage offered classes on Satie; he created a garden outside his studio, where people sat while he performed a twenty-minute concert every Monday, Wednesday, and Friday evening, preceded by a ten-minute talk from his window. There was swimming every afternoon in the campus lake, around which the students darted "like demented butterflies."

In early August, a letter arrived from Charlie Egan, with newspaper reports of Gorky's suicide on July 21. Stunned, Bill, Elaine, and Ray Johnson left their studios and walked down the road for hours. "It's the effect, not the details," Bill murmured as they reminisced. "When Gorky moved to Connecticut, the geographical distance created a personal distance, but only because he was 'there' and I was 'here.'"

At 8:30 P.M. on Saturday evening, August 14, Satie's *Ruse of Medusa* was given its only performance. A highlight of the summer, the comedy in one act was organized by John Cage, who cast Buckminster Fuller as the Baron Medusa, Isaac Rosenfeld (who lectured on Tolstoy) as the baron's butler, Elaine as the baron's daughter Frisette, William Schrauger (an architecture student) as Frisette's suitor, and Merce Cunningham as Jonas, the mechanical monkey. While Merce performed sixty-second episodic dances, John played Satie's music on an out-of-tune piano. Bill created "sets," exaggerated architectural ornamentation around doors, pink-and-gray marbleized pillars for the dining room, and a marbleized desk and chair for the baron's study. Ray Johnson and some of the other students helped create giant props: a huge red telephone, an enormous quill pen and inkwell for signing oversized checks, the baron's elongated top hat, a massive magnifying glass, and a flamboyant candelabrum. A student of Bill's, Mary Outten, made the fanciful costumes. Arthur Penn was the director and a perfectionist, as he drilled everyone's lines for hours each day. During the rehearsal breaks, Fuller mimicked W. C. Fields and whimsically danced with his onstage shadow.

There were frequent parties at the college, and these became "a means of escaping from depression, social intrigues, anxieties about peers, and Albers's tyrannical pronouncements on the students and faculty." One afternoon, Elaine, Bill, Fuller, and Ray Johnson decided to lunch off-campus. Fuller was talking about weights and balances as he gathered silverware from the table and bobby pins from Elaine's coat pockets. Magically, he made a tetrahedron, expanded it to an octahedron, then an icosahedron, all the while expounding on flexibility, expansion, and compression. When Elaine's hamburger arrived, she didn't want to interrupt Fuller's demonstration, and as there were no eating utensils left on the table, she opened her purse, pulled out a pair of canvas pliers, and began eating her hamburger with

it. Fuller stopped abruptly, gazed in bewilderment at the pliers, and announced, "Which brings us to the paradox of tensile strength!"

About a mile from the school there lived an elderly man who used to wait for students to walk by. As they approached, he would run at them with a menacing rake, screaming that they were trampling his grass at the edge of the road. "Each blade of grass costs money!" he would shout. Two days before returning to New York, Elaine and several of the students collected hundreds of pennies; late at night, they carefully placed them on the lawn, gilding the grass in gleaming copper.[54]

1949

Pollock, Elaine, Bill, and Harold Rosenberg went to see Garbo in *Camille* at the Eighth Street Playhouse. Midway through the film, Harold was rolling his eyes during the love scenes, appalled at the sentimentality. He turned to Jackson and was surprised to see tears on his face. "If you don't stop bawling, we'll need a rowboat to get out of this place," Harold murmured in a nauseated tone. A few minutes later, he snickered at Jackson and pretended to puke, which provoked Jackson, who jabbed him in the ribs, eliciting a piercing shout from Harold, who retaliated with a blow to the shoulder, causing Jackson to curse, which infuriated everyone in the theater. An usher appeared and threw them out.

"Booze," said Elaine, "was a talisman that emerged in the art world coinciding with the first days of the Club.[55] It began flowing at gallery openings, encapsulating the present, making it seem everlasting. But it imposed a false sense of being at the center of existence, contracting consciousness while seeming to expand it, and depressing while seeming to stimulate."

Wandering by the seashore in Provincetown, Roy Newell, Joop Sanders, and Bill were drinking all night and vigorously arguing about who was better, Vélazquez, El Greco, or Rubens.[56] Suddenly Roy took off all his clothes, shouted that he was fed up with art history, and announced that he was going to drown himself. He then bolted into the water. Bill and Joop threw off their clothes and raced in to rescue him. As they struggled to bring him ashore, Roy fought them off. People walking by saw the commotion and called the police, claiming there were two naked men in the water trying to drown a third naked man, who was screaming for his life. Bill, Joop, and Roy were arrested and hauled to jail, and Ibram Lassaw was called in the middle of the night to bail them out for ten dollars.[57] The next morning they appeared before a judge and were asked to explain themselves. Suffering from hangovers, they kept interrupting each other and mixing up details, as they tried to convince the judge that Bill and Joop were not attempting to drown Roy, as the police charged. The judge burst out laughing and dismissed the case on condition they get out of town as soon as possible.

Walking up Fourth Avenue one day, goaded by the smell of urine, bus exhaust, and sewer steam, Bill said to Elaine, "We're living like tigers."

1950

Bill was talking to Giorgio Spaventa about wanting to do a crucifixion.[58] "But how do you handle the body?" he asked. Spaventa replied, "You mean you think of HIM in the flesh?!" Bill leaned back, looked askance, and said, "Boy, are you cooked!"

At about 5:30 in the morning, there was an invincible knock on the door. It was Franz Kline.[59] "Is everything okay?" Elaine whispered, as she peered through a crack in the door. Bill woke up. "I just finished a painting and haven't been to sleep," Franz said. "Come over and see it." Bill and Elaine jumped into their clothes, ventured out into the blustery cold morning air, and walked up to Franz's studio. When they arrived, his whole studio seemed like a low passageway leading into a bold black-and-white abstraction, brilliantly lit and still wet. After an hour, they went out for breakfast and talked about the painting all morning.

William Baziotes often exchanged mystery magazines with Elaine and Bill, and the three of them became expert at inventing alternative plots to the serial stories.[60] One day Baziotes complained about the new studio he had rented on the third floor of his building. He was baffled by what appeared to be an increased pull of gravity affecting his paintings, dragging the images down, making the compositions seem heavier in the lower portion of the canvases. After two months he moved back to his first-floor studio.

Elaine watched Bill working frantically to complete *Excavation*. The day after it left the studio for the XXVth Venice Biennale, she remarked that something about it had reminded her of Bruegel's *Triumph of Death*. Bill walked over to his painting table and lifted up a magazine; underneath it was a black-and-white reproduction of the Bruegel.

When Barnett Newman had his first show at the Betty Parsons Gallery, there was a consensus among artists that he wasn't an artist.[61] "He paints talk about art," "Those paintings are mere headlines," and "He's designed a trademark and now he's passing it off as a style" were some of their comments. A few days after the opening, a man approached Franz Kline at the Cedar Bar in a state of fury. "I just came from Barney Newman's first show. How simple can an artist be and get away with it?" he sputtered, "There was absolutely nothing there!" "Nothing?" Franz beamed at him. "How many canvases were in the show?" "Oh, maybe ten or twelve—all exactly the same—just one stripe down the center." "All

the same size?" Franz asked. "Well, no," the man conceded, "they were different sizes." "Same colors?" Franz went on. "Different colors, each canvas painted one flat color—you know, like any house painter could do—then there was this stripe down the center." "All the stripes the same color?" "No, not exactly." "Were they the same width?" The man squinted for a moment. "Let's see. No, I guess not. Some were maybe two inches wide, some a little more." "Was the stripe painted on top of the background color, or was the background color painted around the stripe?" The man paused and began to seem uneasy. "I'm not sure; it was hard to tell. I guess it could have been done either way." "Well, I don't know," said Franz. "It all sounds damn complicated to me."

"There was always bitterness, envy, and competitiveness, even when there was no money at stake," Elaine recalled. "Success just brought those things out in public. Previously, artists didn't talk about their work unless they were in a studio opposite a painting taken out for that purpose. Suddenly there were gallery appointments, critics, deadlines, curators, interviews, etc.—the art world lost its communal coherency. And," she added, "artists always zipped their flies; dealers and museum officials began to button theirs."

Bill applied for a Guggenheim Fellowship at the insistence of Meyer Schapiro, who, with Alfred Barr, Holger Cahill, Isamu Noguchi, Thomas Hess, and Clement Greenberg, recommended him.[62] After a few months, Bill received a letter turning him down. "Well," he said, "at least they can never say 'There goes a Fellow.'"

1951

Jan Roelants, a Dutch painter who was one of the original charter members of the Club, died of starvation. He was very proud, so no one could figure out a way to help him, even though most of the artists were on the verge of starvation themselves.

"An eggshell from the inside" was how John Cage described his sixth-floor apartment on Monroe Street. The main room was translucent white and empty, except for a piano, a slab of white marble on pickled wooden blocks, white cushions for chairs, and five Richard Lippold sculptures. From the many windows there was a stunning view of the East River and the Brooklyn and Manhattan Bridges. When John invited Elaine and Bill for dinner, he would prepare elaborate meals, such as wild rice with chicken livers and eight kinds of wild mushrooms sautéed in wine. For dessert, he would serve three kinds of ice cream that he had spent all day making in a hand-cranked grinder. After dinner one evening, the conversation turned to mothers. John's and Elaine's mothers expressed disapproval about the way they had turned out. "You were a perfect baby," John's mother would insist in a reproving tone, "and now every-

thing's fallen to pieces." "Of music," John would say reassuringly. Ignoring his remark, she would admonish, "You always liked the part of music that isn't music. And those endless flights of stairs—can't someone install an elevator in your building?" John would explain that there wasn't any room in the building for an elevator. "Well," she would inquire, "can't your landlord call Mr. Otis, and have him mount an escalator on the outside of the building to take you up to your floor?"

"Heidegger and the Need of Time" was a lecture the author William Barrett gave at the Club on June 15. Fritz Hensler, a sociologist who attended, was so impressed with the evening's discussion that he invited Barrett and a group of the artists for a weekend at Pine Twig Farm, his country home in Flemington, New Jersey. On a stale July afternoon, Bill, Elaine (whose broken leg was in a cast), Milton Resnick and his girlfriend, Jean Steubing, Lionel Abel, Philip and Marcia Pavia, Franz Kline, Joan and Nancy Ward, William Barrett, and Giorgio Spaventa drove to the farm in three cars. A short while later, Conrad Marca-Relli and his wife, Anita, pulled up to the front entrance "like movie stars, and asked to be shown to their rooms." When Mercedes Matter arrived with Philip Guston and Ray Parker, she was told there was no liquor, so they drove to town and bought scotch, gin, and vodka, which she presented to Fritz as they entered the house.[63] To everyone's dismay, Fritz confiscated the bottles and locked them in his liquor cabinet, insisting that to drink liquor before dinner would ruin the Moselle wine he had selected for the evening. As soon as he left the room, Franz picked open the liquor cabinet, removed the bottles, and passed them around. The guests emptied their wine into the Henslers' potted plants and refilled their glasses with martinis and scotch. Within minutes, they were entertaining themselves with riotous stories, hilarious asides, and uproarious jokes. "Philosophical discussion and metaphysical rhetoric" had been anticipated by the Henslers, but the topics of conversation prepared by Fritz were ignored by everyone, and the more authoritarian he became, the more irreverently they behaved. A lavish dinner of sorrel soup, fresh garden vegetables, wild rice, rack of lamb, and lemon soufflé was virtually lost on the inebriated guests, as they piled food indiscriminately on their plates and gobbled it down.

After dessert Lionel Abel proposed a parlor game, "Truth or Consequences." Fritz and his wife, Ruth, were appalled at the idea and shrank silently into a sofa. Watching the evening unravel before their eyes, they were dismayed by everyone's candor during the unruly game. Finally, at two o'clock in the morning, Fritz stood up in exasperation, announced that there were seventeen guests and eleven beds, and retired with his wife.

For the remainder of the evening, Elaine punctuated the conversations like a chiming clock, "Seventeen people. Eleven beds. Simple." Yet neither she nor anyone else was able to demonstrate the logic implied. Aside from pairs, there were several hidden triangles among the group, and no matter how many arrangements they came up with, at the last moment there was a shortage of beds. Fritz suddenly

appeared in his bathrobe and pleaded with the guests to quiet down, as the noise and laughter had grown to a calamitous level. His bedroom adjoined the living room, and the guests were keeping him and his wife awake, so he urged everyone to move to the kitchen. After a few minutes of sitting on the floor in the hot kitchen, the guests filtered out the back door into the balmy night air.

A full moon shone in the vast starry sky as they wandered into the meadows behind the house, where they discovered a field of wild strawberries, which they freely invaded. Further on they encountered the Henslers' black-faced sheep. Startled, several of the sheep escaped and ran off into an open pasture. They abruptly turned, singled out Milton Resnick, and began to chase him through the tall grass. To everyone's laughter and irrepressible cheers, Franz Kline impersonated John Wayne on horseback and rounded up the flock "like a seasoned cowpoke, steering them back into the corral."

By 5:30 in the morning, Elaine announced that since there was no solution to the bedding problem, she was going to walk back to New York on her crutches. She began climbing toward the road from a field, swaying and limping in her plaster cast, as the first rays of sunlight stung her eyes. Bill ran after her, laughing at the quizzical figure she made. Conrad Marca-Relli got into his car. Soon the other guests jumped into their cars and headed back to New York—unrepentant and carefree—abandoning the quaint, disheveled farmhouse with its flock of sheep, two sleeping hosts, and eleven empty beds.

1952

Bill wrote a poem:

Flowers grow out of your head
All of your fingers make a mouth
But you suck your little toe instead.

Colors live all around your neck
And you have no need of May
O Mary dear, you are a pot and beautiful.

Someone wanted Bill to trade a painting for a new suit. "You'll love it, it's washable!" the man said in a peddling tone. "Washable?" replied Bill, "What's so great about that? That means it can shrink as much as it wants!"

One of Franz Kline's favorite acts was of a movie gangster sniffing a fresh rose in his lapel between murders.

The dealer Sam Kootz asked Franz, "Why can't I get any of you guys?" Franz replied, "Well, you know how it is."[64]

When Franz sold a painting, he would occasionally buy eighteenth-century silver and antique watches but have to resell them a few weeks later at a loss, because he had run out of money. Regardless of his financial state, Franz had an eagle eye for expensive clothes in thrift shops and rarely resisted a bargain. If the clothes didn't fit him, he outfitted his friends.

One day, he found three dozen Civil War ammunition pouches in a Salvation Army store for ten cents apiece. Thinking that his artist friends could use them to carry paint tubes when they traveled, he bought all of them and gave them away. But no one had any money to leave town, so the pouches reappeared a few days later in thrift shops all over the Lower East Side.

Artists at the Cedar Bar bore telltale signs of their trade: the odor of turpentine under their fingernails and traces of paint on their worn cuffs, jackets, and shoes.[65] One night an ardent stranger in a beret began badgering Joan Mitchell, while bragging about his "abstraction paintings."[66] Joan sized him up and said, "Shove off. There's something wrong about you—you look too much the part." The man muttered an epithet and moved away. Later he was heard proclaiming, "I feel Matisse and I are after the same thing in painting." The phrase hung in the air for hours.

Franz Kline approached Elaine in the Cedar Bar one night and said, "How come I can never catch you with people you don't like?"

"Franz's conversation was an interplay of words and pantomime," observed Elaine, "and the effect was an exactness that could not be duplicated or paraphrased. Even when he spoke in half-sentences, he conveyed complete thoughts." Surrounded by friends one evening at the Cedar, Franz imitated the Metro-Goldwyn-Mayer lion roaring: his head swelled larger than life, as he grandly and slowly opened his mouth wider and wider, exposing his ferocious teeth while proudly licking his chops. Then, posing like Ronald Coleman in a French Foreign Legion film, he climbed resolutely onto his horse while giving orders to his regiment. The horse and all of the soldiers suddenly appeared in the bar.

Someone approached Franz with a wealthy friend who said he was interested in buying a big painting. The collector had to leave town tomorrow, but could he return with his wife to the studio in one week? Franz set a date with him and then spent the week cleaning his studio and finishing several large canvases. He borrowed money for wine and cheese and was prepared for the guests at 5:00 P.M. By midnight he realized the guy had been bluffing. Resigned, he trudged over to the Cedar with his wine and

cheese, handed it out, and began his story, "First they tell you to dive, then they pull the water away. . . ."

Jackson Pollock felt he had a monopoly on the cowboy image, and one night at the Cedar he brutally attacked a guy who caricatured him as he made his entrance. The man pranced up to the bar like a cowboy in spike heels and shouted several times in falsetto voice, "Set 'em up, boys!" He then turned and winked at Jackson. Jackson lunged at him like a battering ram. As the brawl exploded, everyone started screaming at the top of their voices. Sitting in a booth near the fight, Harold Rosenberg began pounding his fist on the table, scowling. "Impossible! What! What? Im-poss-ible!!" After ten minutes, no one could hear anything, no matter how loud they yelled: the more one person shouted, the more everyone else had to shout. Jackson and his "punching bag" were thrown out onto the street as the noise inside rose to a deafening level. Someone "who was not an artist" approached Harold and pleaded, "This is pandemonium! Is it necessary to yell at such a vociferous pitch? Please make them stop!" Harold shot back, "Are you out of your mind? We're engaged in discussions of the highest order and it's not enough to argue with our antagonists—we must annihilate them!"

Franz had been asked to take care of a dog for some friends who were going on vacation. "It was a big beautiful Great Dane," he told Bill. "It was highly intelligent and very affectionate. I didn't have any money for food and I didn't have anything to feed it. I was living on coffee and sugar and I gave it some. You can't feed a dog coffee and sugar. I came home one night and the dog was dead. Out of hunger, he had eaten half a cake of old laundry soap. I guess an artist can survive where animals die."

1953

A few hours after they arrived at the Castellis' summer house in East Hampton, Bill bought spackling, sandpaper, plasterboard, house paint, and tools.[67] He immediately began planing a door, rescreening windows, and putting up wallboard in the area of the house where he and Elaine were going to paint for the summer. Within a few days, however, the household was subjected to extended visits from "artistic neighbors," the first of whom was Johnny Myers. "He appeared at the door one lazy afternoon and then turned and called 'Poets!'" Elaine said. "And sure enough, three little poets came scampering after him through the fields."[68] On another occasion, they were entertained by watching Jackson wrestle Mary Clyde on the front lawn.[69] "A remarkably strong girl, she held her own," Elaine affirmed. It looked as though the summer would soon disappear in distractions, so Bill never finished his carpentry work.

The hostess of a dinner party hid a microphone in a large vase of flowers and placed it at the center of

her dining table; Hans Hofmann was seated directly in front of it.[70] Later in the evening, while serving coffee in her elegant sitting room, the hostess showed everyone the tape and proudly played it for them. Disregarding the woman's subterfuge, Hans stood up and exclaimed, "That tape isn't accurate. It may be what we said, but it isn't what we meant. I insist on destroying it." Hans left with the tape under his arm.

1954

In a rare birthday greeting, Bill's mother announced that she was coming to America "for a short visit." A few days later, Lutz Sander stopped by Elaine and Bill's with news of a large red house for rent in Bridgehampton: "Cheap—$600 for the whole summer—eight big rooms. We could get a couple of artists together, split the rent, and we'd all have studios in the country!"[71] It was an extravagant sum, but Lutz, Franz, and Nancy Ward were interested, and they all agreed that they would be delighted to have Bill's mother as a houseguest. Bill and Elaine were relieved at the prospect of taking his mother out of the city, and everyone was looking forward to a communal household. But diffident friends warned, "Six of you in one house for the whole summer? You'll be mortal enemies by the second week in June."

They drove out to Long Island a few days later, eager to see the house and make arrangements. There were large bedrooms for Bill's mother, Lutz, and each of the two couples, plus a big parlor, a dining room, one bathroom, and an outhouse. Three extra rooms on the first floor would serve as studios for Elaine, Franz, and Lutz; Bill decided to use the garage as his studio, freeing an upstairs bedroom for weekend guests.[72] Lutz speculated that the architect of the house had been an escape artist, because two doors went in and out of every room. "I'll take care of the cooking," he proposed. "I'll take care of the salads," Elaine replied. Bill offered to do the dishes. "I'll watch," said Franz, adding, "Some people rinse away their guilt by watching other people do their dishes." There was no furniture except for some old beds, a few stray chairs, and one large table.

When "Oma" stepped onto the gangway of the ocean liner a few weeks later, everyone shouted to "a short, stocky woman with a determined forehead and childlike blue eyes." As she approached them, Bill said under his breath, "She's only five feet tall, but to me she looms ten." On the way to the car, Oma began speaking to everyone in Dutch, which no one understood except Bill, and he was having trouble. He began answering in half-Dutch, struggling to remember his native tongue as she continued talking, certain she was being understood by everyone. Oma felt instantly at home with Lutz and Franz; Lutz spoke German with her and Franz invented his own version of "Dutch on the spot," which she adopted in return. "Passen die budder, please," Franz would say, or "Wansen ein bier?" as he raised a glass. Oma would answer, "Tenk you," and everyone would laugh. Soon they were all speaking "Kline Dutch" among themselves, so that she could be included in their conversations.

A few days after Oma arrived, Franz decided to cook dinner in her honor; he bought a dozen thick lamb chops, which he broiled as everyone sat around the kitchen. He cooked like an emcee and talked like a male Scheherazade, "leaping from the drama of baseball and the art of blowing bubbles to Delacroix's harem paintings and the unveiling of the Statue of Liberty." "A schlemoozle is a guy who has no luck," he chimed through the smoke. "A schlemiel is a guy who hands you a drink and spills it all over your lap. A schlemoozle is the guy with the lap," he announced, as the lamb chops burned to a clump of greasy cinders.[73]

Oma and Lutz did most of the cooking that summer. Their specialties were a thick country soup with meats and vegetables, potatoes cooked in a casserole of cheese and crisp bacon, and everyone's favorite, turnip bread. At first, there was no money for dishes, so they used paper plates and paper cups, which they washed assiduously every day. They soon acquired a set of bright purple plates from a yard sale on one of their twilight walks in the neighborhood.

Everyone was enthralled with the borrowed television set, which tuned in only one station that seemed to broadcast only one program: old Charlie Chan movies. They laughed uproariously one evening when the television suddenly began to elongate the actors El Greco style. A lady in an alley screamed convulsively as she was pulled vertically by the television; the more she yelled, the more she stretched, as her voice expanded into a deafening squeal. On another night, a crowd of panic-stricken villagers transformed into fun-house giants; their heads bobbed on and off the screen as they gestured like startled mimes. During one of the cliffhangers, a stray cat wandered into the house and adopted Franz. "That cat is like a work of art—it has charisma," he declared, naming it Lana, because of her long eyelashes, golden color, and sultry gaze.

The summer unfolded in a caravan of cars cavorting from beach outings and baseball games to picnics and all-night parties, and the red house soon became known as "hangover haven." One balmy morning in mid-June, Jackson drove up in his old Model A truck and staggered drunkenly toward the front door. He began chasing Elaine through the house, taunting her into a wrestling match. When the cat passed by, Jackson picked it up by the ears, suspending it in midair, then swung it over his head, pretending to pull its ears off. Bill, Lutz, and Franz had gone to East Hampton to install shelving in a bookstore owned by their friends, Carol and Donald Braider.[74] Elaine managed to run down the back staircase, telephone the store, and summon everyone: "Hurry home. Jackson's here, drunk." The Braiders immediately drove them back to the house, and when they pulled into the driveway, they saw Jackson chasing Elaine through the elm trees. Bill and Franz leapt out of the car and cried to Jackson; soon all of them were on the ground, wrestling and laughing. Suddenly, Jackson pushed them away, sat up in disbelief, and let out a pugnacious groan, "I feel like I broke my ankle!" Franz examined the swelling and confirmed it, "You sure have." "Things like this just don't happen to me!" Jackson blurted defiantly. Throughout his life he had emerged miraculously from accidents. Two years before, he had

41

smashed up a Cadillac convertible: the car was totaled, trees were destroyed, but he walked away unscathed. He kept repeating, "I'm not the type to break a bone," as he was helped into the Braiders' car to be taken to the East Hampton Clinic.[75]

The truck was left behind, and Franz and Elaine immediately seized the opportunity to learn how to drive. Lutz gave them a five-minute lesson on the use of the clutch, and after an hour of circling the house without stalling, Franz and Elaine were confident enough to venture out onto the highway. "Anyone for the beach?" shouted Franz, as he crouched over the steering wheel like a gangster in a getaway car. A few days later, they drove to Riverhead for learner permits, but no one with a license ever accompanied them on their outings. In July they surrendered the truck to Jackson's wife, Lee Krasner, and Franz bought a 1937 Lincoln Roadster. Overnight that car acquired the smell of a saloon, as Franz insisted on balancing his beer cans on the dashboard; they inevitably slipped and spilled, soaking the seats and floor.

By mid-July Lutz would announce at breakfast in the voice of a butler, "Some people got up in the middle of the night, pilfered through the refrigerator, ate sandwiches, and went to bed with the kitchen in disarray," or "Somebody left the butter out and it was buzzing with flies this morning." Franz didn't like cleaning up; neither did Nancy, and no one went into their room all summer.

After several days of muggy weather, Jackson, Nancy, Elaine, and Bill decided to go for a picnic and country drive, with Franz as the chauffeur. Within minutes, the car was racing around blind curves, cutting corners, swerving over lines, barely missing oncoming traffic. "Can't you drive this tub down the middle of the road?" Elaine asked drily. Franz crouched over the steering wheel with a beer can in his hand, growing impatient with the backseat drivers. He wouldn't slow down, so Elaine got out at a traffic light and said she was returning home on foot. Six hours later, they showed up at the house. There had been an accident: Franz had veered into a parked car at five miles an hour. They had been taken to a police station and detained, because none of them had money for the fine. Eventually, the police released them because Jackson's head had cracked the windshield and he needed a few stitches; Bill injured his knee, and Nancy broke three ribs.

One revelous night, Harold Rosenberg drove everyone to four different parties, and on the way home, they stopped off at a bustling roadside bar called the Elm Tree Inn. Elaine had to use the bathroom, but since there was a long waiting line, she decided to go outside behind the building. She stepped lightly through the thick brambles and moonlit bushes, accomplished her mission, and staggered back. But on the way she tripped and fell, then rested on the soft ground for a moment, "gazing up at the stars, enjoying the hazy sensations." A train whistled calmly in the distance. As she breathed in the fresh night air, she gradually became aware of a faint vibration and a metal bar running underneath her back. She groped around with her hands and touched wooden boards. "Railroad tracks," slowly seeped into her head, "and I'm lying on them!" Everything began spinning wildly, as she dizzily

dragged herself up on all fours, just in time to catch the eye of a train speeding toward her. She crawled forward: tracks; to the right: tracks; left: more tracks—they were everywhere, spreading out in all directions. Suddenly there was a silhouette of a tree in the moonlight. "Tracks can't go through that!" she told herself, crashing toward it as the train sped past her feet. Back inside the bar, she recounted what had happened, assuring everyone, "The moral is not that drinking could cause my death, but that I could extricate myself from any situation, even if I were drunk."

On a breezy afternoon a few days later Franz announced, "Let's go to the thrift shop," as he and Elaine strolled through Bridgehampton. When they entered the shop, they noticed a flamboyant blonde in a polka-dot beach outfit. She whistled incessantly in a high-piercing shrill, as she chewed gum, slammed cupboards, rummaged through clothes, and inspected bric-a-brac. After twenty minutes, Franz nudged Elaine and whispered out of the side of his mouth, "Whenever a girl whistles in a bathing suit, the Virgin Mary cries."

There were picnics and clambakes at the beaches, where Franz mastered opening clams with a palette knife. "Why are there no 'old mistress' paintings and why don't we have 'mistresspieces?' " he asked, while savoring a clam on the half shell.

In the backyard that summer Franz painted several easel-size abstractions titled *Hampton*, and late one evening under a starry sky, he created a mural by the ocean. Elaine, Nancy, and Bill sat atop the dunes as Franz proceeded down, picking up a piece of driftwood along the way. As he approached the shoreline, he began to carve into the thick wet sand for over an hour. Moonlight magically appeared, filling the gashes with deep black shadows. When he finished, he studied it carefully, then slowly climbed up the dunes, halting occasionally and looking back, until he rejoined the others. As they surveyed the huge abstraction over fifty feet long and thirty feet wide, he said in a rueful tone, "I may as well paint my paintings in the sand and let the sea take them away." Below, the waves silently approached, slowly erasing the image, as an imperceptible breeze wafted the scent of privet hedges blooming on distant estates.

The apotheosis of the summer was the croquet party, and everyone was determined that it would be inclusive rather than exclusive. Nancy, who was a commercial artist, made a color ink drawing of the house for invitations, which read, "Willem de Kooning, Elaine de Kooning, Ludwig Sander, Nancy Ward, Franz Kline invite you to a croquet party at the Red House, Montauk Highway, Saturday, August 7, 3:00–7:00; Refreshments, Bridgehampton." On the huge lawn encircling the house, there would be cocktails in the afternoon and long games of croquet until sunset. For outdoor party decorations, Franz, Bill, and Lutz made flowers at Elaine's behest. "You can be as far-fetched as you want, but we have to have at least six of any flower you make, so I can pin them on the same bush," she directed. "And it's all right to paint purple and black flowers with big yellow blotches, but if you're going to work that hard on every flower, we'll never fill a bush. We need batches of each flower." "Now we're in prison doing

piecework," Franz grumbled. Bill moaned, "It's more like therapy in a lunatic asylum." When they were finished, everyone agreed that the flowers looked perfectly preposterous, especially Franz's "lady evening glories." Bill decided the outhouse needed renovating, so he painted the doors and seats white, then picked up a brush dipped in black enamel and ran it through the wet paint, instantly transforming the surfaces into marble. The inside walls were re-covered with wallboard and painted in pink and orange stripes, mimicking festive wallpaper. For lighting Bill nailed little shelves to the side walls, on which Nancy perched altar candles they had won at a church bazaar a few days before.

On the morning of the party, Elaine and Nancy spent more than two hours attaching the flowers to bushes and trees with wire. "Something's missing," Elaine decided. She drove off to town and bought a half dozen vials of cheap perfume, which she used to douse the flowers; they smelled "grisly." Over two hundred dollars was collected for "libations"—wine, scotch, bourbon, vodka, gin, beer, soda, and fruit juices—all of which were set out on a large table. (Early in the evening, a woman sat on the edge of the table and brought all of the bottles and glasses crashing onto the lawn.) "Gin marks the skin," Nancy confided to Elaine, "and any kind of whisky will put weight on you, but you can drink as much wine as you want." The two of them wore billowing floral skirts with huge red-and-white petticoats they had found in a thrift shop a few days before the party. Nancy prepared more than one hundred "damp cream cheese and cucumber sandwiches" for the guests. There were also fresh potato and tuna-fish salads, a wash basin brimming with fresh fruit, and a laundry basket filled with six dozen hard-boiled eggs. Hordes of people arrived by trains from New York City, and cars drove up from all over the Hamptons bearing tons of food and liquor. Bill and Franz played croquet until dusk with the children, who laughed at their over-zealous antics. The men were more competitive than any of the children, yet despite their persistence, they lost, to everyone's amusement. At one point, Lana the cat arrived at the party with a dead chipmunk and presented it to a baby crawling on the back lawn. The baby was about to put the chipmunk in its mouth headfirst, when Bill's mother rushed over and intercepted it.

As night fell, the cacophony roared. Two phonographs blasted simultaneously, one in the parlor, one outside, as guests reeled about everywhere, dancing drunkenly on the lawn and drifting aimlessly through the house. Someone brought a Polaroid camera with enough black-and-white film to take about forty pictures. A game of charades commenced in the parlor as everyone passed the camera around, taking snapshots of each player adopting their pet character: miser, spendthrift, coquette, rake, cad, flirt, bigot, tyrant, bully, coward, buffoon, cuckold, braggart, snob, jerk, sap, dope, philanderer, gossip, bum, pedant, reactionary, aesthete, etc. The more film they shot, the more hilarious and incongruous the photographs looked. In a corner of the dining room, Franz told a "paintless, pointless story," mimicking Matisse drawing an elaborate self-portrait on his own face.

By about 3:00 A.M., Elaine vanished upstairs to sleep while the party dragged on indoors and out. She woke the next morning at about 10:00 A.M., leaving Bill sound asleep in bed. Lutz was wandering

about in the serene sunlight, quietly gathering up half-filled glasses, paper plates, abandoned food, and bottles strewn all over the lawn. Honey bees and flies were in everything. "There's someone's shoe," he whispered, "and here's someone's stocking: I found it in the backyard under this bra, soaked in a pool of gin." Several artists and friends were snoring under the elm trees; those who had made it into the house dozed peacefully on the floor.

On Tuesday morning, August 31, Elaine and Bill were jolted awake by the sound of a massive tree crashing on top of the garage, which spontaneously collapsed to the ground. Hurricane Carol had struck Long Island, with rain and winds raging at over one hundred miles per hour.[76] Bill's studio was crushed, his paintings and drawings destroyed; almost the entire summer's work was obliterated in an instant. *Two Women in the Country*, some pastels, and a few ink drawings survived, because he had carried them indoors a few weeks earlier, to hang in the house for the croquet party. Oma wrote a book that summer, which went unread because it was in Dutch.

1955

On a hot August afternoon on Fifty-seventh Street, Bill ran into Barnett Newman, who was wearing a new, fastidiously tailored gray suit. Bill looked him up and down and said, "Gee, I'd like to have a tin suit like that." "Tin?!" replied Newman in dismay. "It's one hundred percent Italian silk! And handmade, too!"[77]

1956

In late spring, Jackson Pollock visited Ibram Lassaw and told him that he wanted to learn how to weld. He said he wanted to start making sculpture.

"Monet water lilies choked in brambles" was one artist's assessment of Pollock's paintings shortly after he died. But Elaine defended him, saying, "From the very beginning, Jackson's painting had virility and he handled paint like a whip. True, he liked being a 'naughty boy,' seeing how far he could go and get away with it; he was highly image-conscious and not only with his paintings: he deliberately played out a role in his life. And it was true there was no such thing as a long conversation—only fits and starts— but talking about art wasn't the issue. Doing it was all that mattered to him."

1958

"I worked like a dog on that painting," Bill said with a bemused smile. "And when I woke up the next morning I thought I was seeing things: hand prints were painted all over it." His daughter Lisa, who was two years old at the time, had risen earlier and begun to play with Bill's brushes and paint tubes.[78] She discovered wet ocher paint on the palette, rubbed her tiny hands in it,

walked up to the canvas, and gently patted it. "At first I was furious," Bill conceded, "but the more I looked at it, the more I liked it, and I soon realized I couldn't have done better myself." He affectionately named the painting *Lisbeth's Painting*.[79]

Some artists were discussing the character of Clyfford Still's work.[80] Bill remarked, "His paintings have a defensive stance: they leer at you with argumentative edges, as if he expected you to criticize them."

1959

For his new studio, Bill wanted to buy a piece of land adjoining the Lassaws' in the Springs section of East Hampton. But the property proved to be landlocked, and he was unable to obtain an access permit from the road. On June 20, he bought a plot of land nearby, measuring 4.79 acres, from Wilfrid M. Zogbaum.[81] His address on the deed of sale was listed as 88 East Tenth Street in New York.

1960

When Franz Kline saw an early Coca-Cola painting by Andy Warhol he said, "Now that's one hell of a social realist painting!"

1961

"The pop artists boasted about being 'original' and criticized us for copying Michelangelo," Bill said. "But they looked like copycats to us, grabbing whatever they saw and putting their names on it."

1962

On March 16, Bill filed an application for a building permit to construct a studio in East Hampton, at an estimated cost of $54,000.[82] The structure was conceived as a two-floor residence and one-floor studio with approximately 5,400 square feet of space.[83] Each time Bill visited the property, he studied the movement of light across the land in order to select a site for the building. Originally, he had planned the studio so that the easel wall faced north, with east and west walls made of glass. After several months, he rotated the building in his sketches, so that the easel wall faced east, with the north wall glass and the south wall a combination of solid wall and glass. An additional source of daylight would be a narrow skylight positioned above the easel, extending most of the width of the studio. His purpose was to have an even light reverberating around the studio all day, reflected off the walls, ceiling, and floor.

1963

From the beginning, nautical allusions were evident throughout Bill's studio designs.[84] The shape of the building resembled a barge angled to a pier; a prow jutted midair into the studio; staircases from the studio and first-floor living area were framed with white metal railings like those on a ship; two massive furnaces resembled those in the boiler room of a freighter; the basement was positioned under a section of the living area like a ship's hold; and maple storage benches lined the living area and studio walls, adapted from seats on the Staten Island Ferry.[85]

Decades of New York City living influenced the building's expanse and loftlike scale. The front entrance opened directly into the kitchen and dining area; large windows filled most of the walls in the first-floor living area and studio; a long narrow skylight was positioned above the easel; the dining table was built into the floor (reminiscent of furniture in Bill's first loft at 156 West Twenty-second Street);[86] a second-floor bathroom had six-foot-high walls opened to the ceiling (like the bedroom in his second loft at 156 West Twenty-second Street);[87] and the exterior walls were concave and convex, adapted from Herman Cherry's Cooper Square studio, and the view up Fourth Avenue from Tenth Street.[88]

Industrial materials were integrated throughout the building. Plumbing pipe was used for hand railings inside and deck railings outside; steel girders, trusses, and cement ceilings were exposed (painted white, disguising their weight); raw cinder blocks supported shelving adjacent to the kitchen area; two commercial refrigerators, two stainless steel sinks, and a commercial stove with two ovens were installed in the kitchen; the dining table and bedroom dressing tables were made of butcher block; an industrial-grade exhaust fan was installed in the studio; catwalks gave access to massive studio lights with circuit breakers for switches; both floors of the living area were set with commercial-grade terra-cotta tiles;[89] a terrazzo floor was poured in the studio;[90] and the interior paint color, a warm mushroom white, was tinted with "a touch of industrial green."

Several aspects of the studio were left unresolved. Access to the exterior studio door was blocked by wall benches; a steel beam stood six feet in from the front door; an outdoor swimming pool for which a permit had been obtained was never built;[91] an exterior door on the second floor led "to nowhere" (facing southeast into the backyard with an unimpeded drop to the pavement below);[92] and the freestanding fireplace, redesigned four times, was abandoned in its last stage (it had been painted dark orange, opened through to the opposite side, and shaped like a woman's torso).[93]

1964

Elaine and Bill approached the new Cedar Tavern on University Place, two blocks up from the original Cedar Bar. Although it was midnight when they peered inside, they didn't recognize anyone. Further up the street, they stopped in front of the United Farms grocery store and

gazed at the opulent fruit and vegetable display in the window. "Terrific! Like a seventeenth-century Dutch still life," Bill said wistfully. They continued walking and suddenly recognized Hans Hofmann coming toward them. Not seeing them, he briskly passed by. As they turned and looked, Elaine said, "If he stops in front of that grocery store, let's go up to him." Just at that moment, Hofmann paused and glanced at the produce. Elaine and Bill shouted, "Hans!" and rushed toward him. He turned and cried, "Bill! Hélène!" As they threw their arms around each other, Hofmann gazed up and down the empty streets and asked, "But where are all the artists? Where is everyone?"

1966

"When I walk into a gallery now, I don't see anything," Bill said. "It's as if the artists spent all their time trying to find ways how not to do anything. Just because you don't do anything, doesn't mean you've said something. And, as Harold Rosenberg once pointed out, just because you don't say something doesn't mean it's true."

1967

Bill was reading through a magazine article on "de Kooning." He suddenly laughed and said, "That's me that's him?" Harold Rosenberg replied, "Yes, and it cost an awful lot of money to keep Mahatma Gandhi living in poverty."

1969

While Bill was visiting Japan, he was taken to see Mount Fuji.[94] He gazed at it silently and after a few moments, remarked, "Why didn't they drop the bomb on that? It wouldn't have killed anyone and they could still make their point."

"I knew I couldn't carve," Bill acknowledged, "so I never considered making sculpture. But when I tried modeling clay in Italy, I liked the way it worked in my hands; if something didn't look right, I could destroy it and start all over, the way I did with my paintings."[95]

1972

While working on his *Clamdigger* sculpture in East Hampton, Bill said it used to remind him of Jo-Jo, the studio mannequin he had constructed during the thirties in New York.[96]

1974

Occasionally, people dropped by unannounced, and one afternoon the studio

became crowded with visitors, some of whom Bill hardly knew. Infuriated by the impromptu party, he withdrew into a chair in the living area, turned on the television, and kept his eyes glued to it. "TV lets people under the same roof ignore each other," he remarked to a woman with bedroom eyes who was sitting on the couch. "My, what a fine voice you have," she purred. The twelve-year-old son of an art dealer wandered over to Bill and asked him to come into the studio; when they walked in together, the dealer approached them and beamed with approval. "Thanksgiving dinner!" the boy proclaimed as he gazed up at the turbulent brush strokes in one of Bill's abstractions. "Yeah, I can see the wishbone, mashed potatoes, stuffing, and the gravy. It's all there. I want it." Bill looked at the boy's father and said, "That kid's got no religion."

1976

One summer morning a woman knocked urgently at Bill's door. "I have two children and an ulcer. Can I borrow some ice cubes?" she asked. "Sure, help yourself," Bill replied, letting her in. The woman walked over to the freezer, opened the door and jumped back, yelling, "Hey, there's a dead bird in here!" A few weeks earlier, Bill had interrupted his painting at the sound of a thud against the studio windows; he rushed outside and came upon a bluebird, its wings outstretched, lying dead in the grass. "I put it in the freezer," Bill explained, "so the cat wouldn't eat it." "But I can make artificial flowers out of those feathers!" the woman declared. Grabbing the bird by its tail, she merrily ran out the door and leapt into her car. As she vanished down the driveway, she pointed her finger and cried, "You should get a bird bath and put it over there by those bleeding hearts." Bill waved to her and shouted, "You should be in show business!"

1978

"I had a quiet profile. I used to paint quiet paintings," Bill said. "Before I met Elaine, I painted quiet men. Then I started to paint wild women."[97]

1979

"Since the mid-sixties, many paintings have a value only in relation to the date or the price on them," Bill observed.

1980

Visitors to the studio were discussing God, justice, and the sentencing of criminals. After a pause, Elaine said, "I can only conceive of god as inconceivable." "Yes," Bill added, "and I don't have any convictions except my paintings."

Bill was glancing through a catalogue of his 1970s paintings. He put it down and said, "I'd like to make some paintings that have no technique."[98]

1981

On May 26, Marisol was a houseguest at Bill's.[99] She came down to breakfast the following morning and asked, "Do dealers sleep in my room?" Bill answered, "Why?" "It smells bad," she replied. Later, the conversation turned to some women's libbers, who had recently contacted Bill about using one of his women paintings on their new poster. Marisol said, "They make me uneasy. When they talk, I feel vagina on my face."

Someone said to Bill, "You've lost your color." Bill responded, "I can do without it. Now you could say I'm using color by absence."

On June 23, the day after traveling to Washington to accept an award for Bill, Elaine remarked about how "ordinary" the carpets were in the White House. "Well, it's a Protestant country," Bill said.

1982

A student asked Bill why he had never studied with a famous artist when he was young. "Nothing grows under big trees," Bill replied. Then the young man asked him how to become a famous artist. "What are you painting?" Bill inquired. The student confided, "I'm having a terrible time. All I seem to be making are bad paintings; the more I paint, the worse I get." Bill said, "Don't tell anyone; they might steal your idea."

After watching a television program about left and right brain functions, Bill remarked, "So if painting is about the wordless part of the brain, I guess you could say I always lived in my right brain, but I think it's more connected than that."

1983

"There has never been a painting I haven't struggled with," Bill said, as he walked out of the studio one evening. "The difference now is sometimes I can make them seem less cumbersome."[100]

Bill admitted he was afraid of flying. "But I could be a courageous groundhog."

"I thought you once told Harold Rosenberg you would never make a red, white, and blue painting like Mondrian," a friend said to Bill. "Yes," he replied, "but Mondrian separated the colors."

1984

Early in the evening, Bill went upstairs "to take a snooze before going to sleep." About an hour later, he came downstairs and described a dream he had. "I was standing by myself, looking out a small window. Inside it was very dark, but outside the sun and the stars were high in the sky, making everything glow with an unreal light. There was a green meadow with a milkmaid in it and she was poised looking at me. I kept thinking how quiet it was, so I waved, but she didn't seem to understand, and I suddenly felt childhood memories rushing into my head. I thought I heard her say, 'Who is?' Then I felt an awful melancholy."

1985

After working all day in the studio, Bill noted, "A finished painting is a reminder of what not to do tomorrow."

While glancing through some color photographs of his eighties paintings, Bill gave them the following titles: *Sleeping Figure* (*Untitled II*, 1984); *Milkmaid* (*Untitled X*, 1984); *Four Corners (Untitled XII*, 1984); *The Waiting Room* (#34, 1984); *Porch in a Landscape* (#35, 1984); *Rider* (*Untitled VII*, 1985); *The Privileged* (*Untitled XX*, 1985); *The Ears of a Barking Dog* (#43, 1985); *Running* (#45, 1985).[101]

1986

Mr. Mongo, the white Angora house cat, had turquoise paint on the tips of his paws. He approached Bill and meowed assertively. Bill turned and said, "You know what he's saying? 'You're taking me for granted and I don't like it.'"

Asked about a small circle in the painting *Untitled III* (1986), Bill replied casually, "That's the belly button."

1987

In the late 1980s hyperactive forms began to appear in Bill's paintings. "I'm back to a full palette with off-toned colors," he observed. "Before, it was about knowing what I didn't know. Now, it's about not knowing that I know."

1988

Sitting in one of his twin rocking chairs, Bill gazed around the studio at his recent paintings and said, "Sometimes I'm afraid of yellow."

PLATES

1979

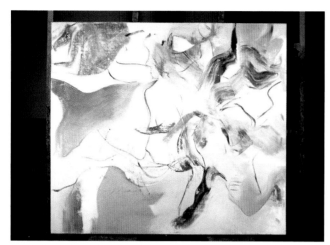

1980

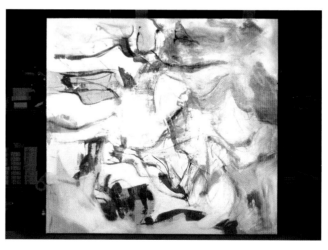

1980

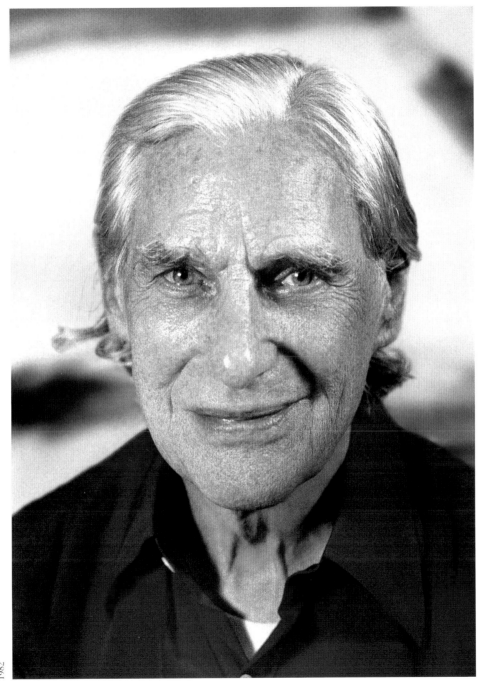

1982

55

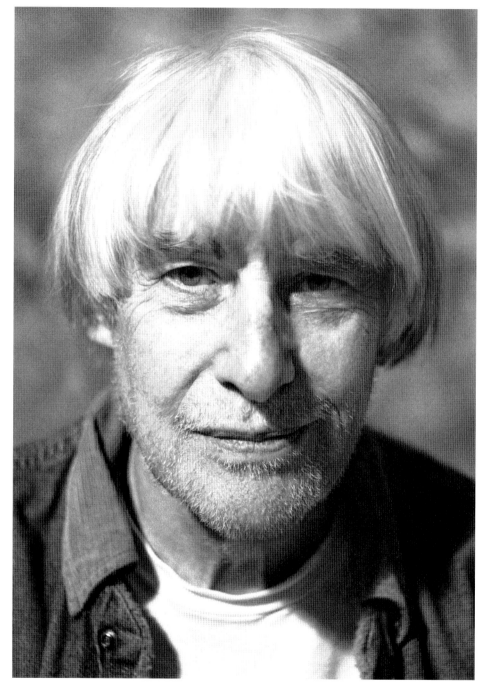

1979

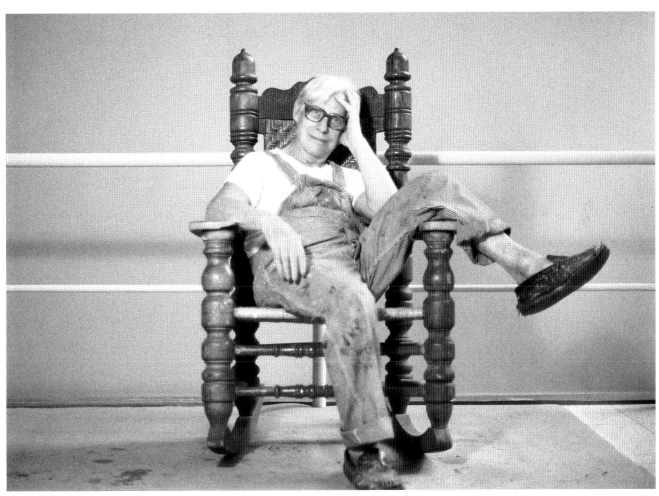

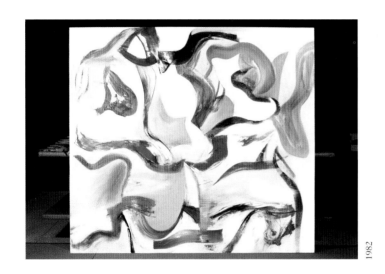

1982

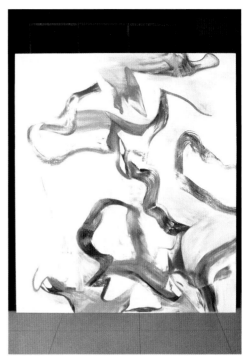

1982

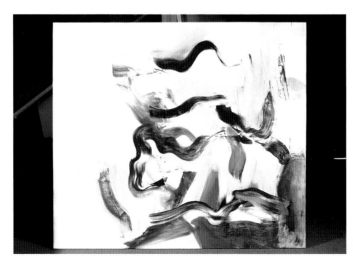

1982

58

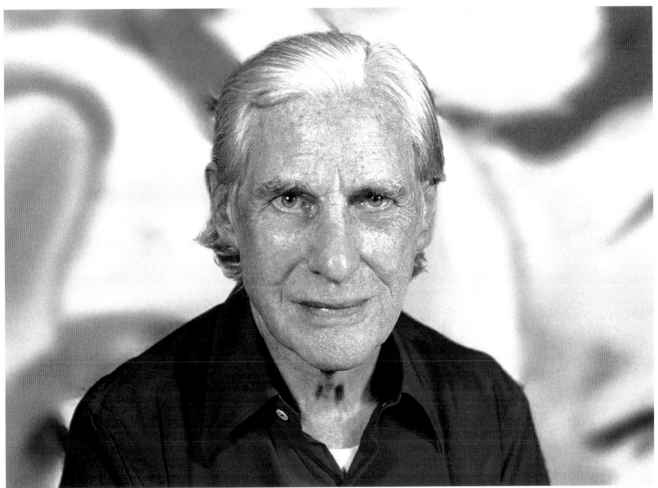

1982

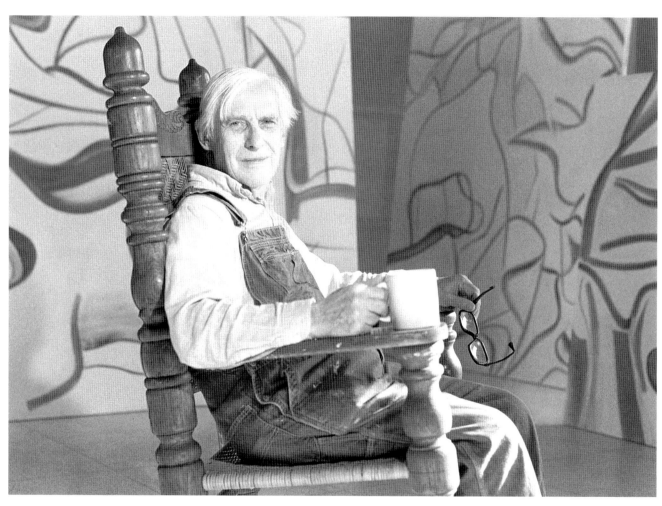

1984

60

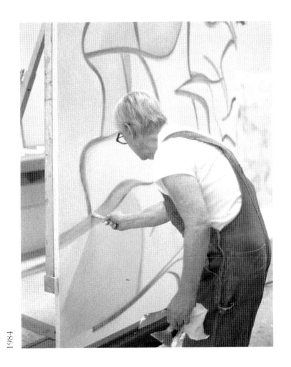

1984

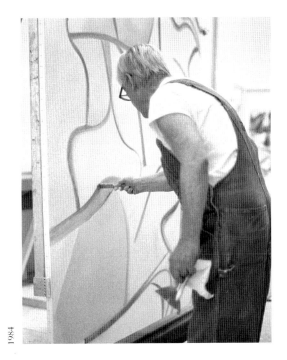

1984

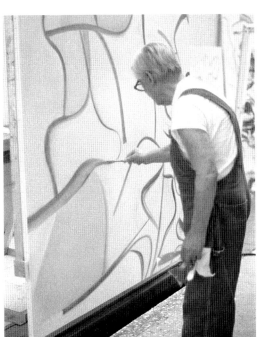

1984

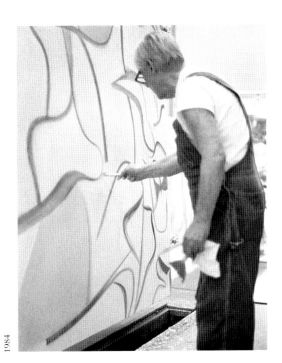

1984

1984

1983

63

1984

1984

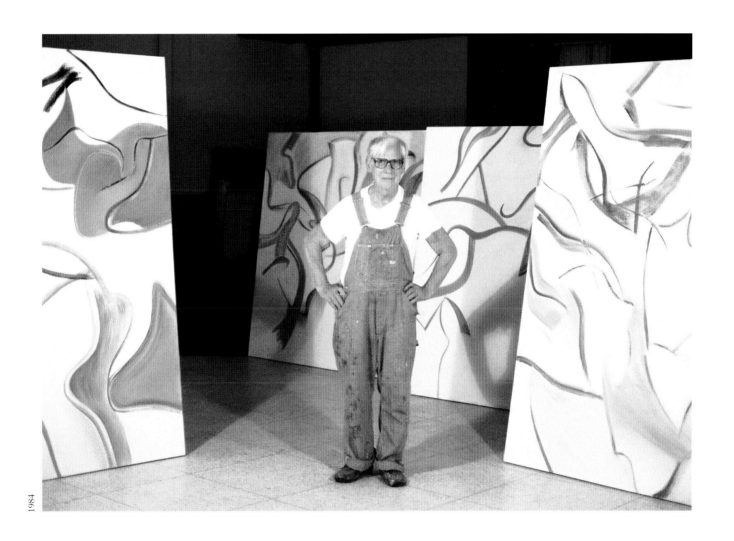

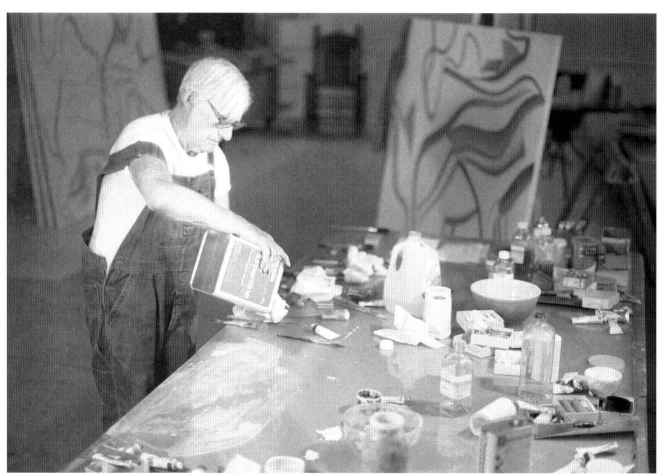

1984

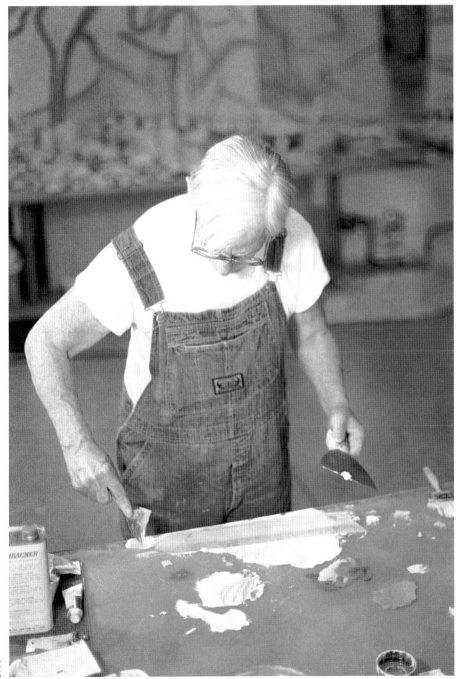

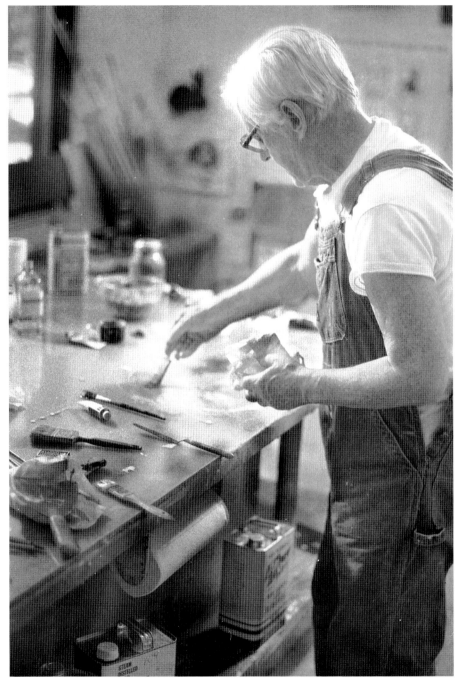

1984

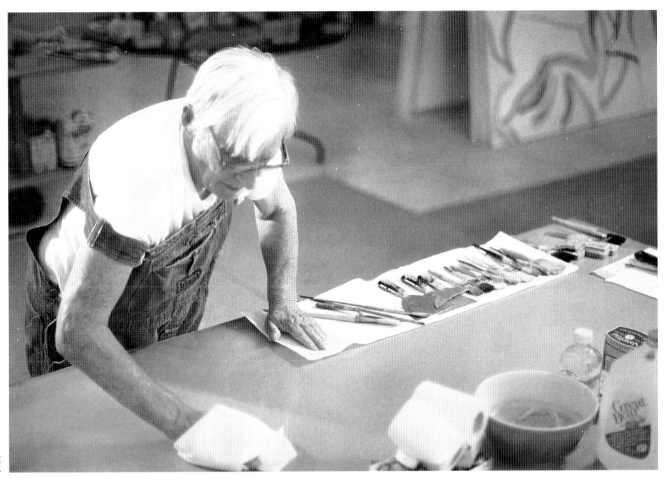

1984

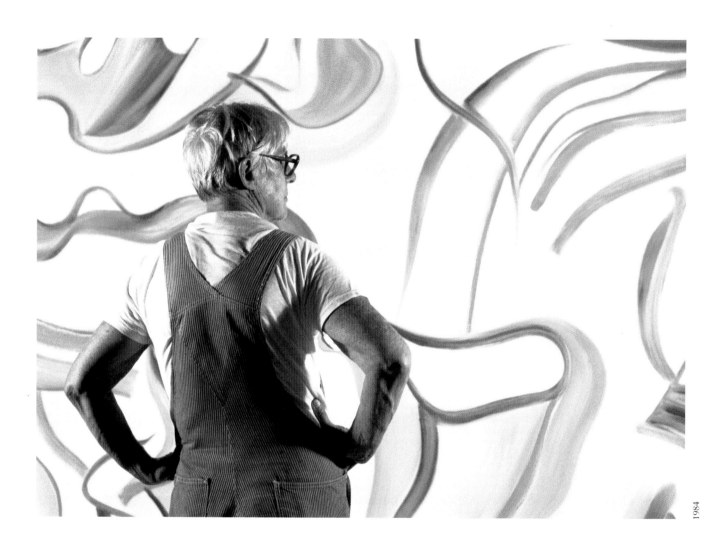

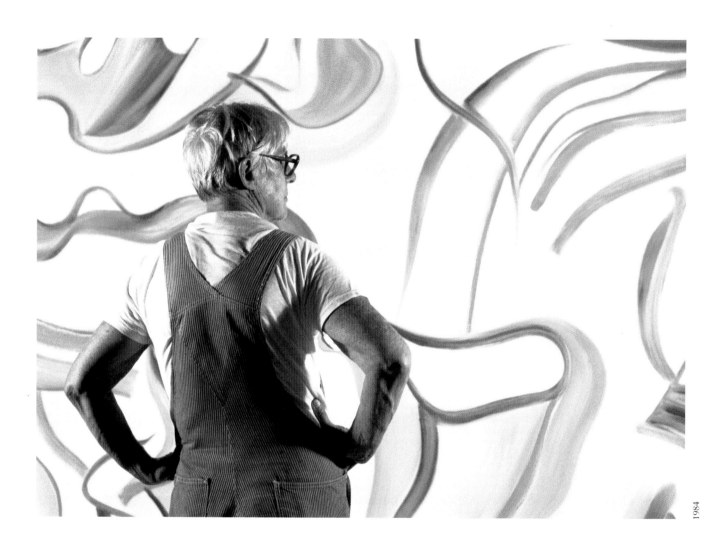1984

70

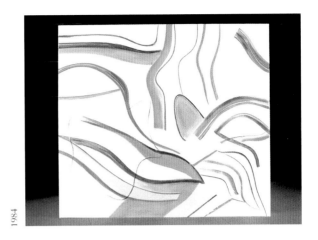

1984

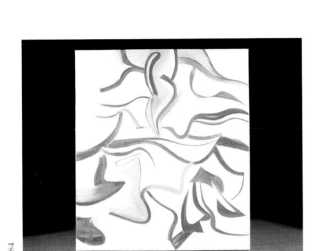

1984

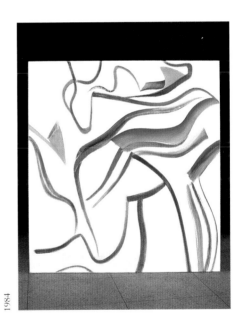

1984

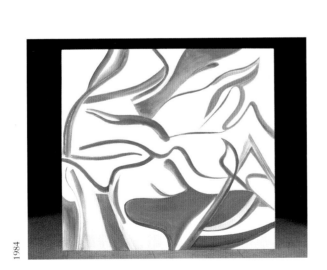

1984

71

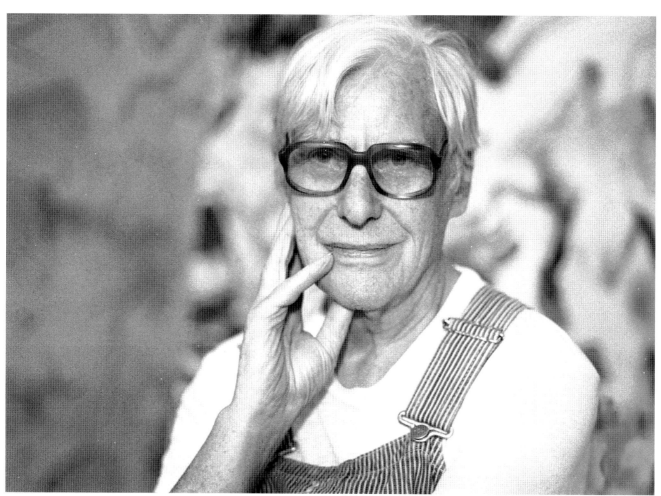

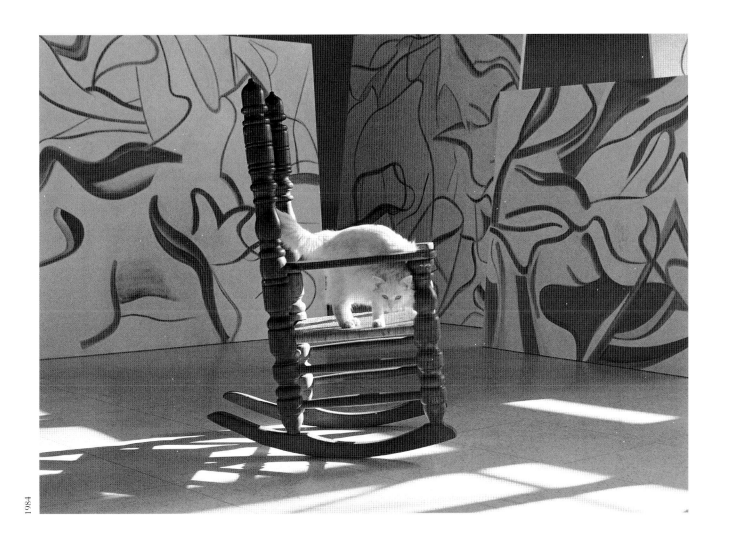

1984

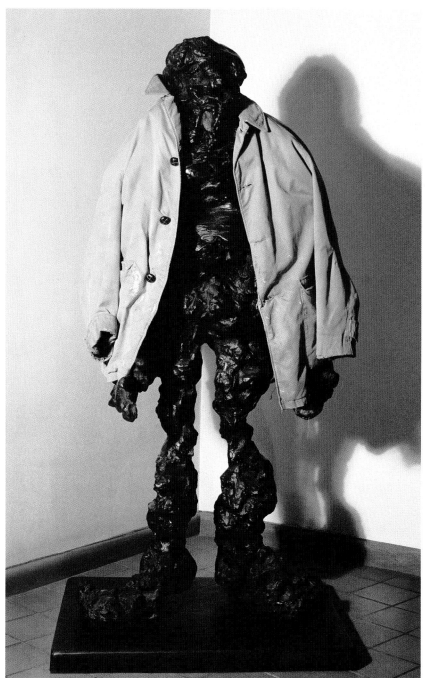

1986

1986

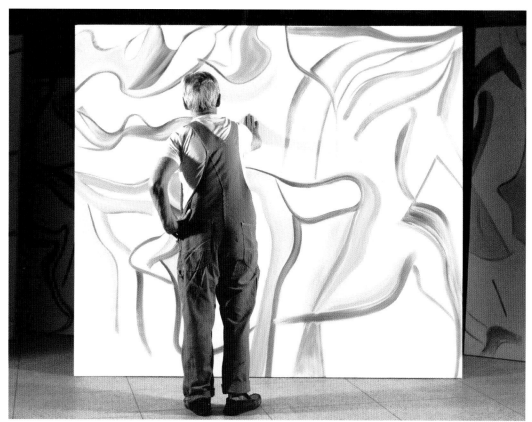

1984

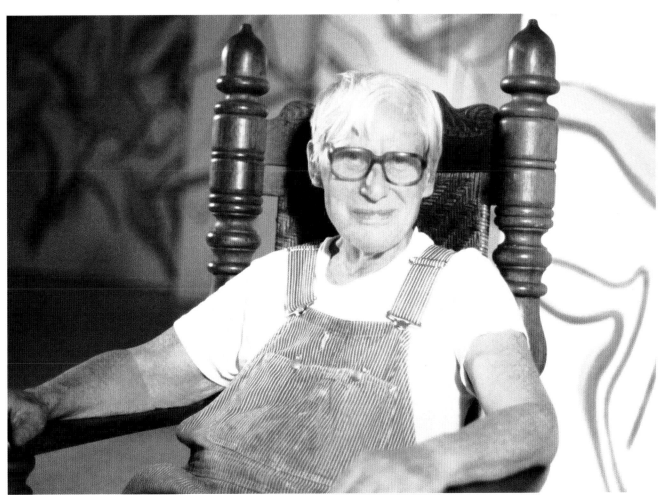

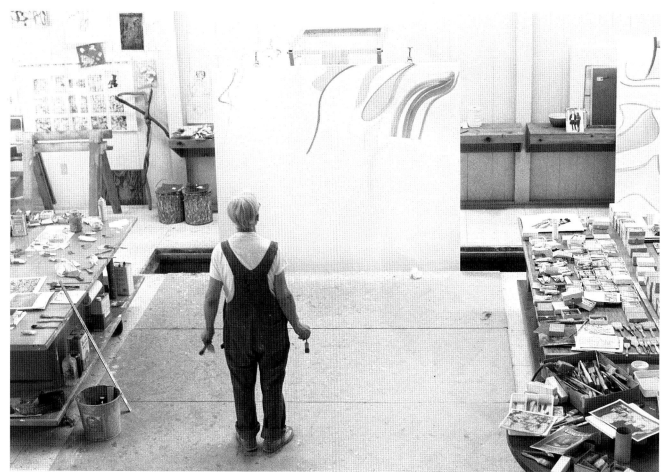

1985

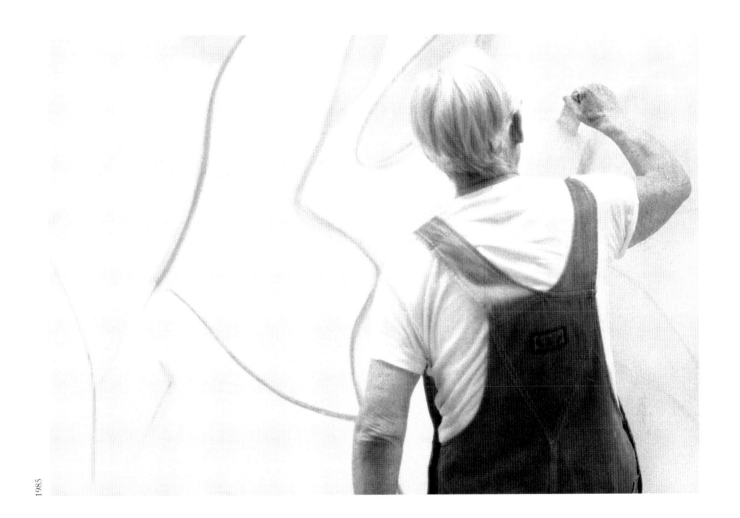

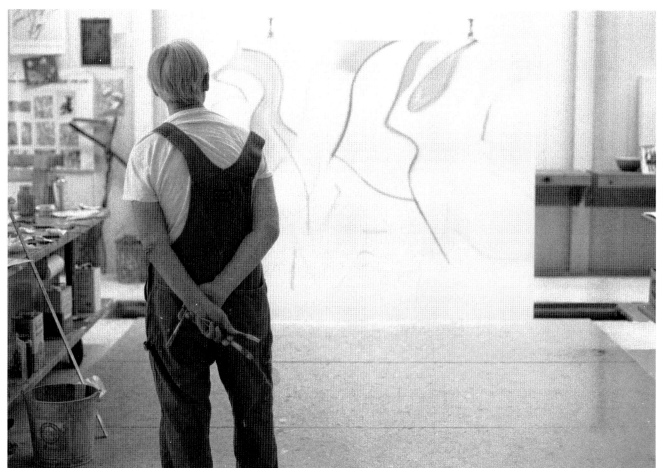

1985

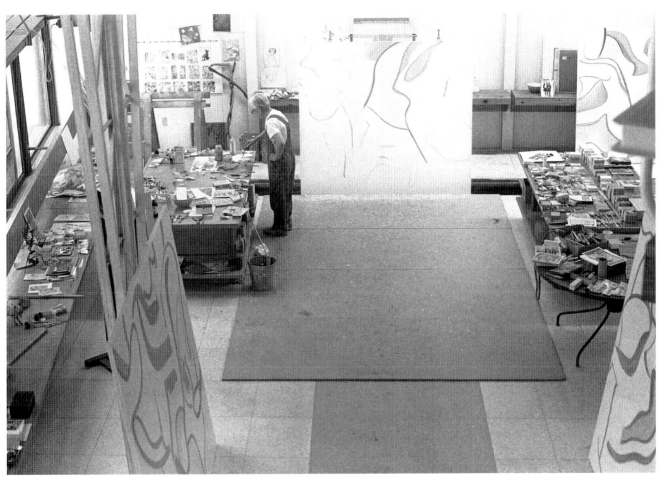

1985

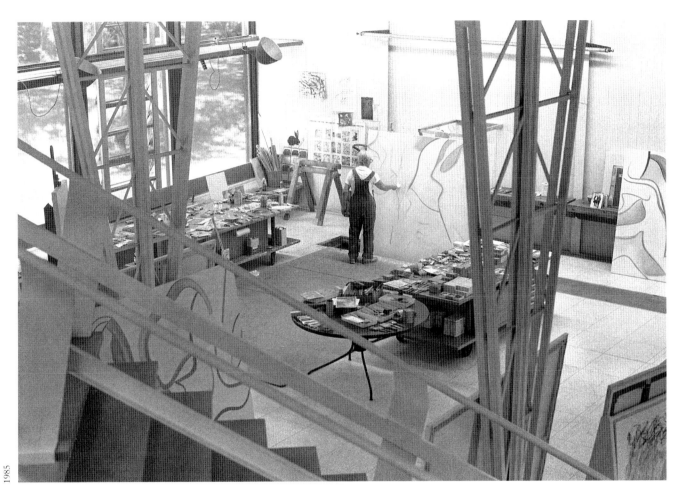

83

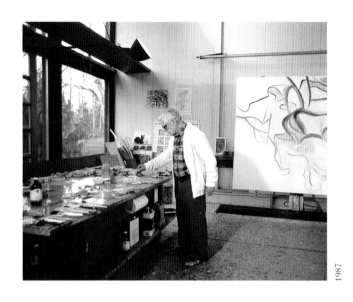
1987

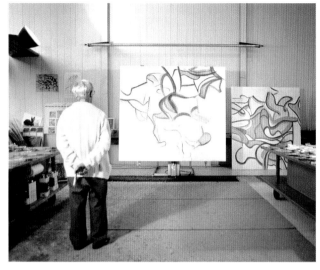
1987

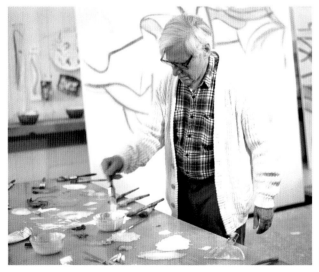
1987

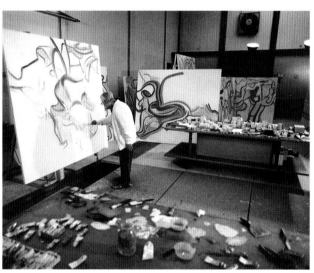
1987

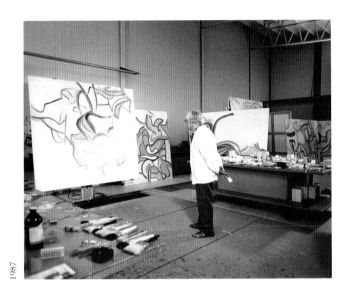

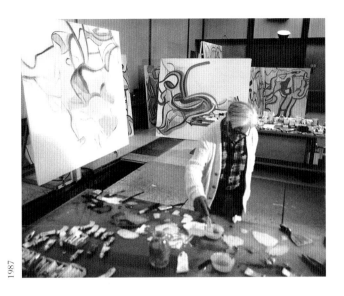

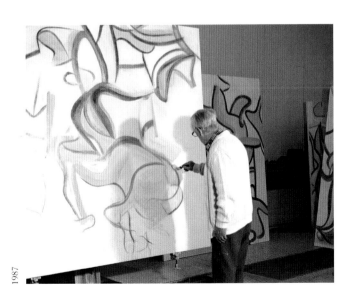

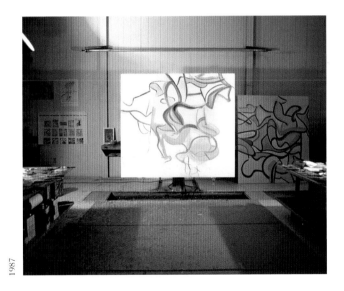

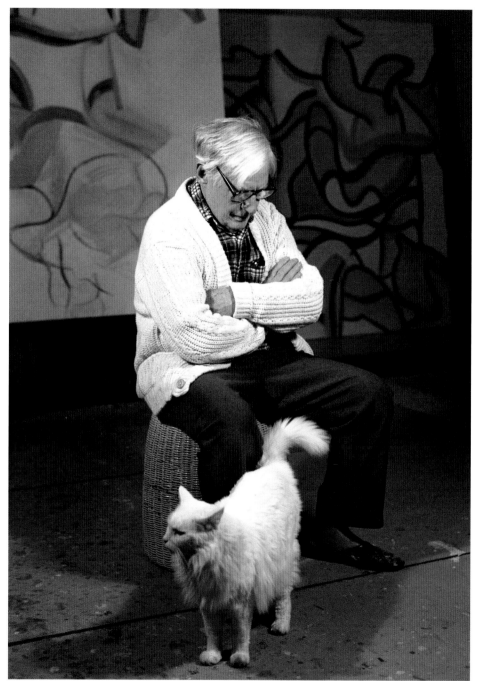

1987

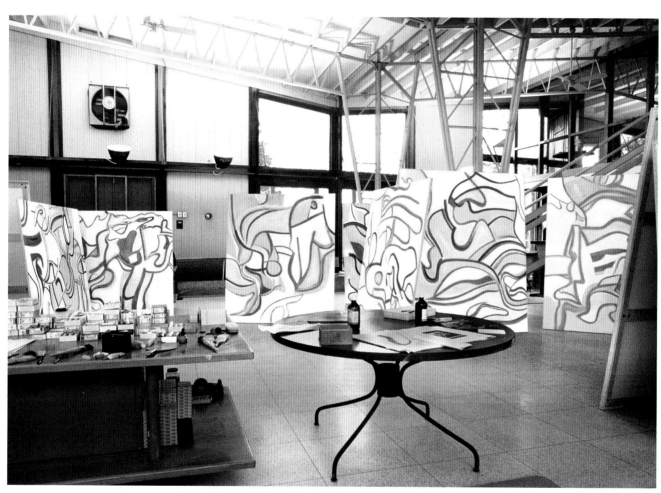

1987

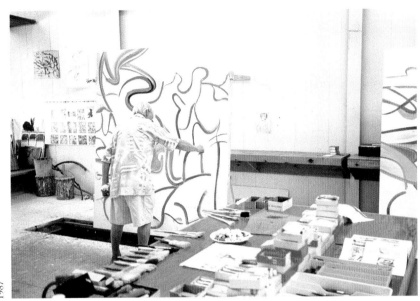

1987

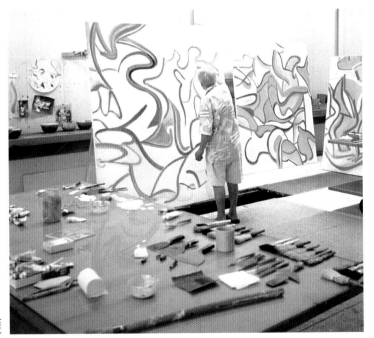

1987

1984

89

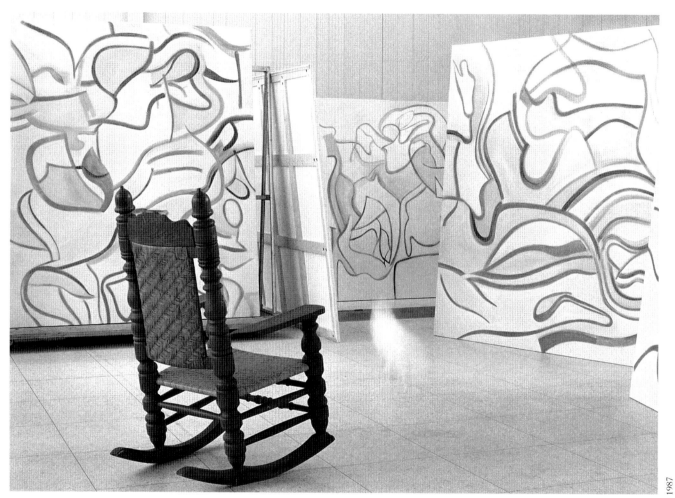

1987

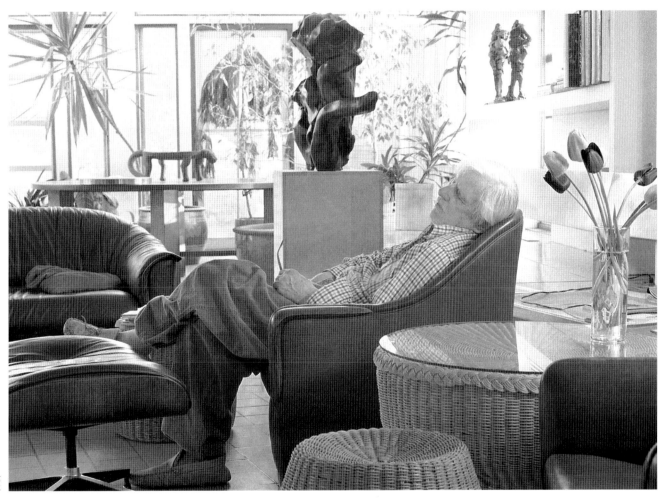

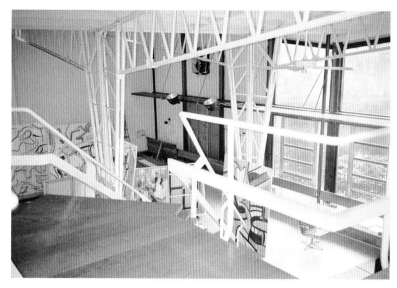

1987

1987

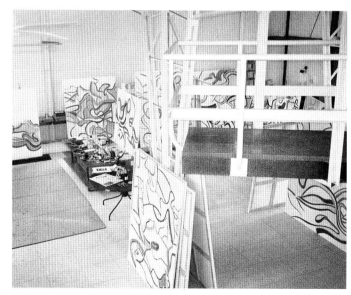

1987

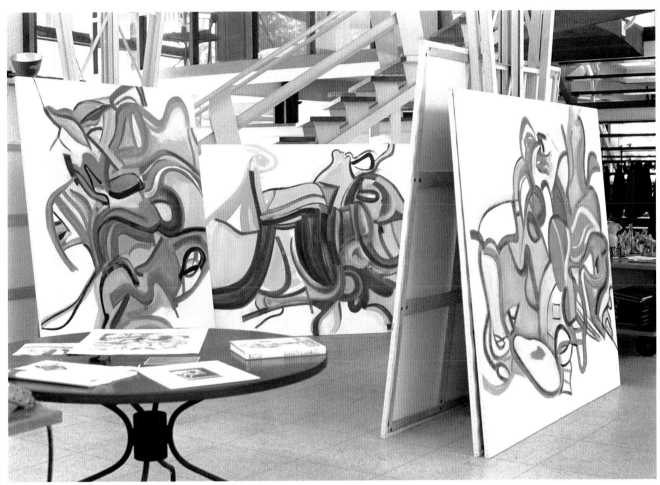

1988

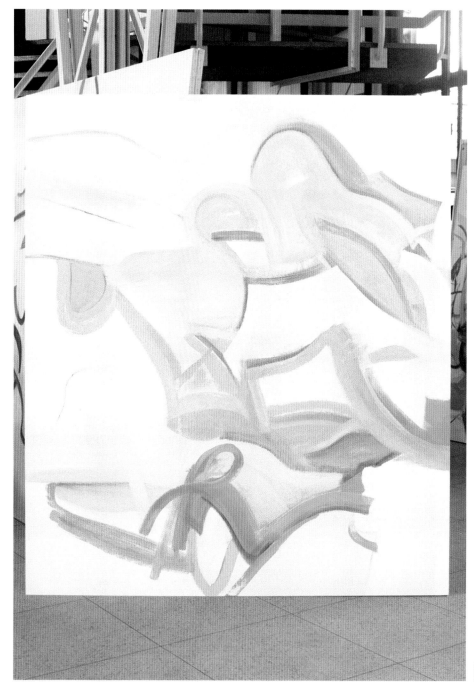

1988

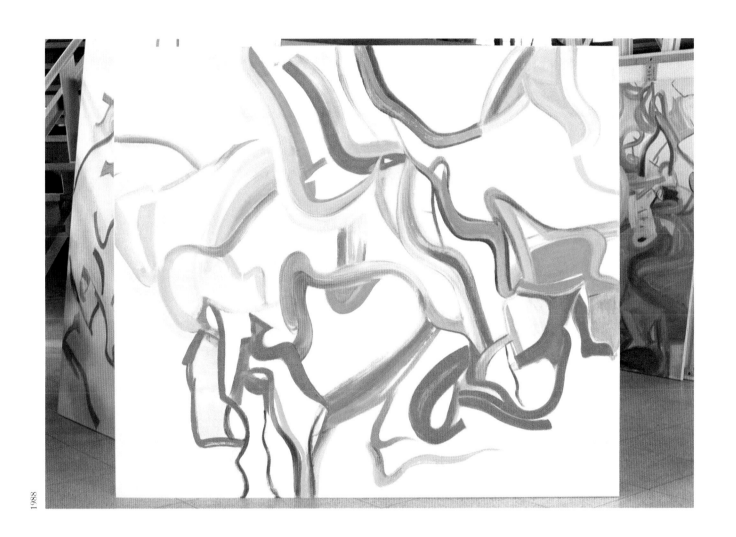

1988

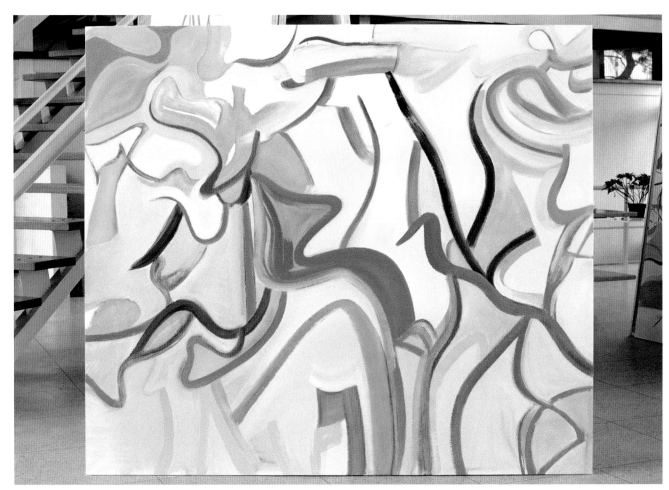

1988

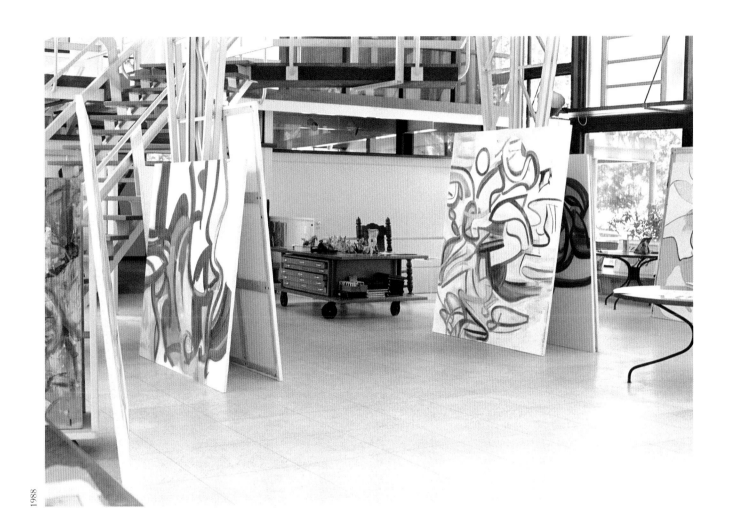

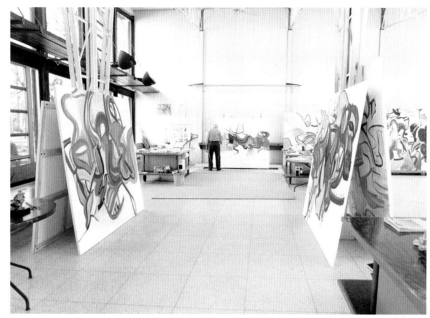

1989

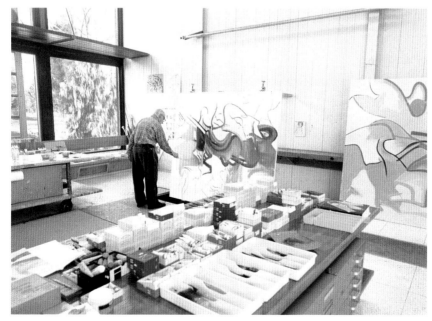

1989

98

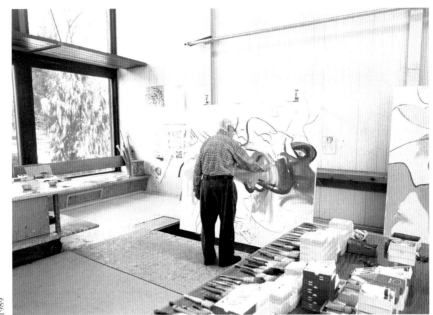

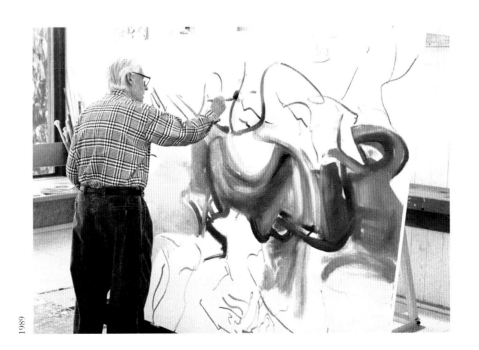

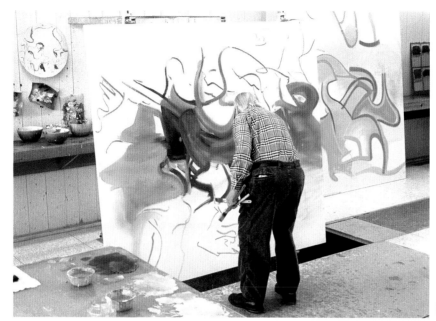

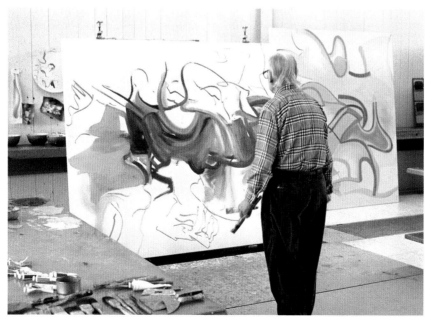

1989

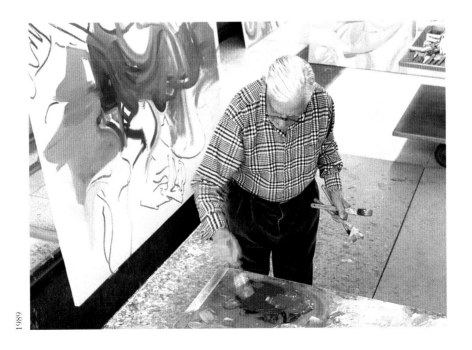

1989

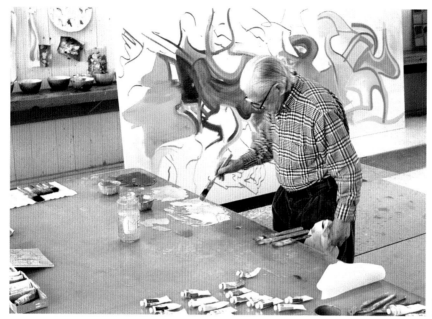

1989

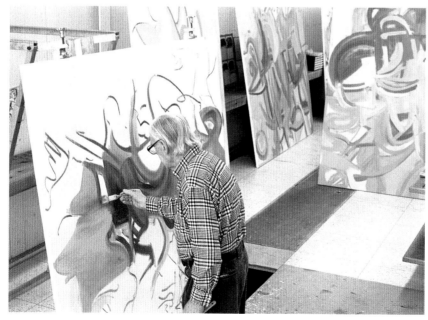

1989

102

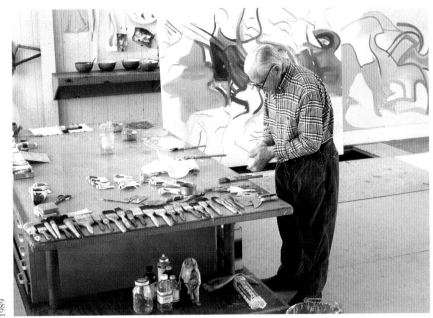

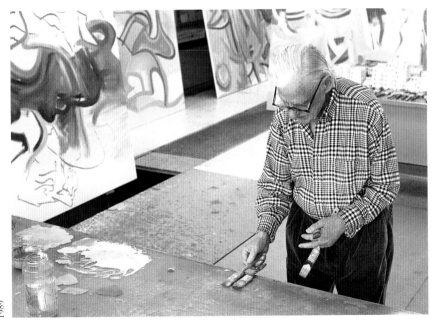

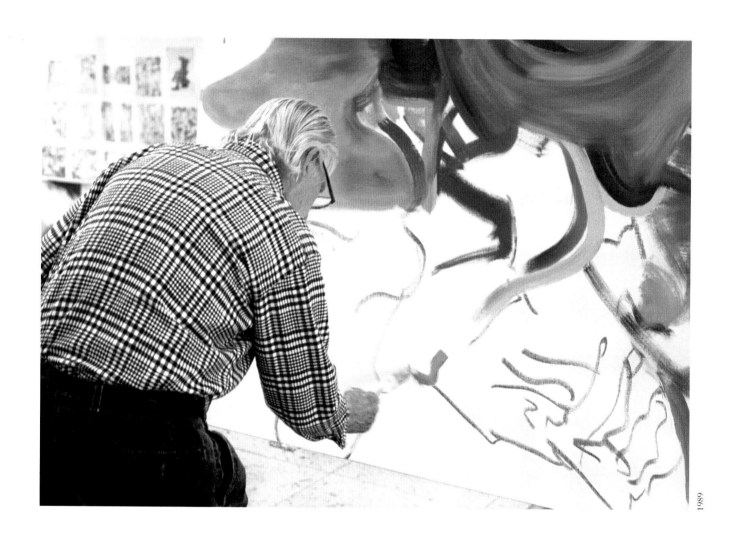

1989

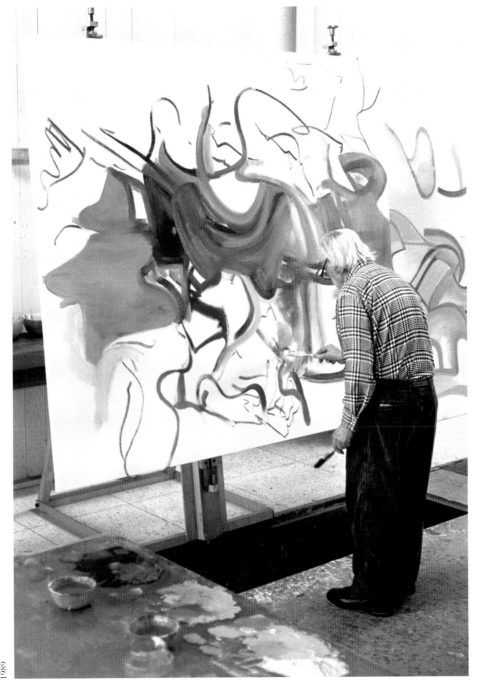

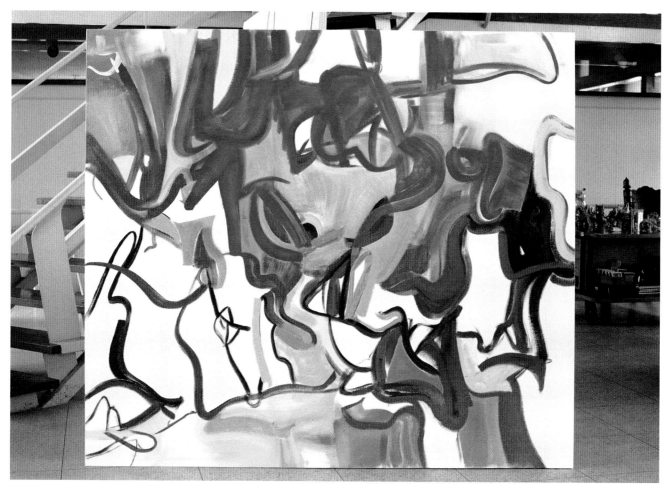

1988

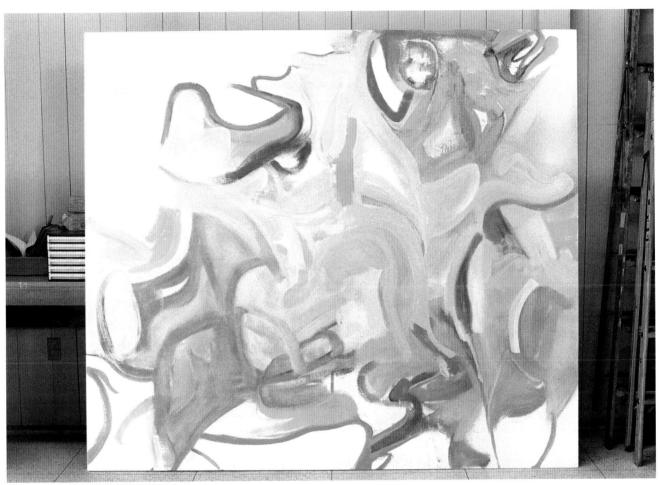

1988

107

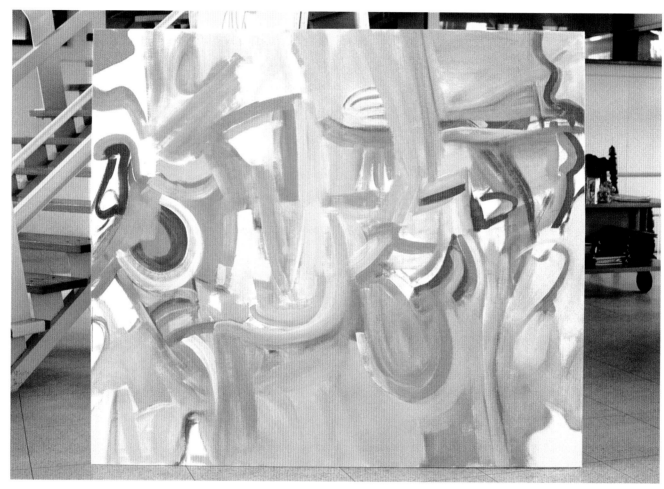

1988

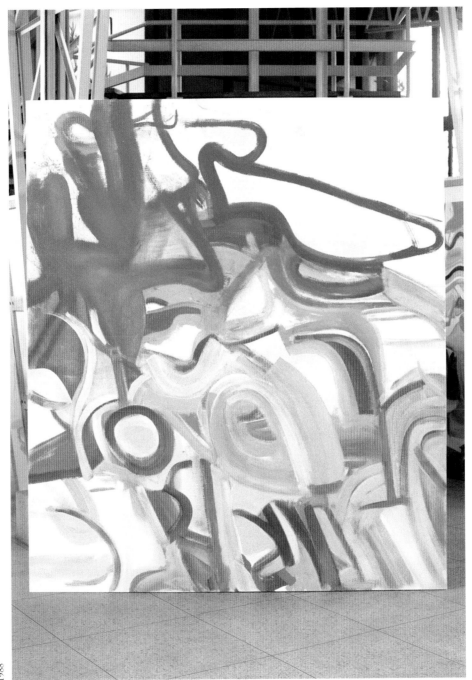

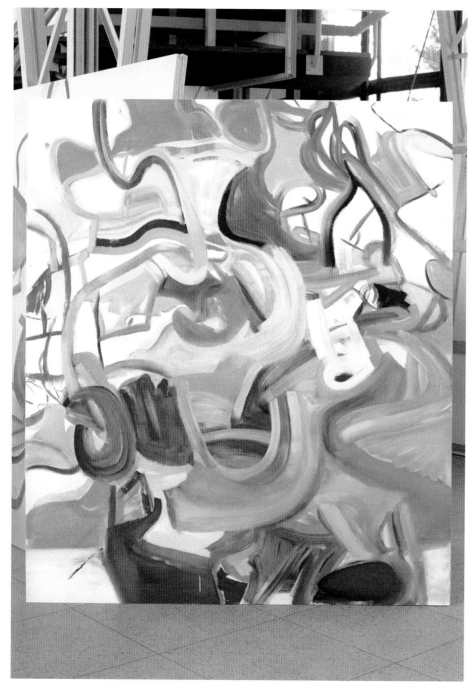

1988

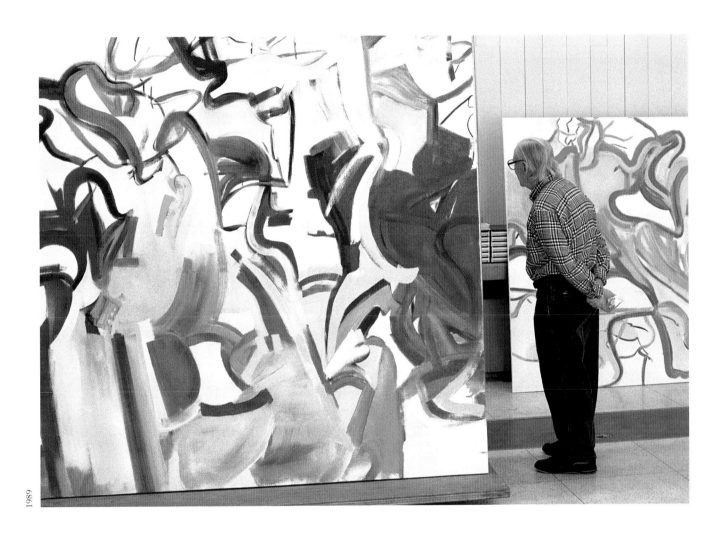

111

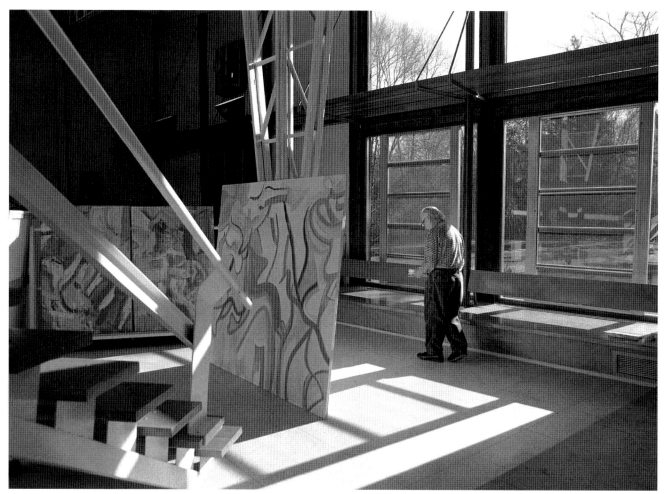

1989

112

NOTES

1. M. Knoedler & Co., New York, "De Kooning: Paintings and Drawings Since 1963," Nov. 14–Dec. 2, 1967. This was de Kooning's first solo exhibition at M. Knoedler & Co. (14 East Fifty-seventh Street), comprising sixty-eight paintings and drawings installed on two floors in four rooms, with additional hangings in the main hallway and staircase. The gallery held a second solo exhibition, "De Kooning, January 1968–March 1969," March 4–22, 1969. M. Knoedler & Cie (85 bis, Faubourg St. Honoré, Paris), mounted two solo exhibitions: "De Kooning: peintures récentes," June 4–29, 1968, and "Willem de Kooning: New Lithographs," Sept. 28–Oct. 23, 1971.

2. On his seventy-fifth birthday, April 24, 1979, Bill was named an Officer of the Order of Orange-Nassau by representatives of the Dutch government in a ceremony at the Guggenheim Museum. Lee and Monique Eastman invited me to attend the event with them, and they introduced me to Bill and Elaine on that occasion.

3. Within an hour of my addressing them as Mr. and Mrs. de Kooning, Bill laughed and said, "It's after office hours. Call me Bill," to which Elaine added, "and please call me Elaine."

4. Guild Hall, East Hampton, "Willem de Kooning: Works from 1951–1981," May 23–July 19, 1981. The performance took place at the opening reception on the evening of May 22.

 Music to Paintings, a recording comprising all of my music inspired by contemporary painting, was released on LP in 1983 and on CD in 1995.

5. Edvard Lieber, *Seven Portraits* (1983, 16mm, color, sound, 21 minutes): Willem de Kooning, Leonard Bernstein, Robert Rauschenberg, Tennessee Williams, Andy Warhol, John Cage, Liv Ullmann. The film was featured in five major international film festivals, including the 1984 Berlin Film Festival and the 1984 São Paulo Film Festival.

6. Lee V. Eastman (1910–1991) was Bill's lawyer and friend for more than three decades. Bill's daughter, Lisa de Kooning, and Lee's son, John L. Eastman, were appointed co-conservators on September 27, 1989.

7. Leendert de Kooning (1867–1955) and Cornelia Nobel (1877–1968) had two children: Marie Cornelia (van Meurs) (1899–1984), and Willem (1904–1997). Leendert was a distributor of beers, wines, and soft drinks; Cornelia was the proprietress of a café bar frequented by sailors in Rotterdam. They divorced in 1907 and both remarried in 1908. Leendert married Neeltje Been and had three children: Nel (1909–1996), Leendert (b. 1914), and Henny (1918–1990). Cornelia married Jacobus Lassooy and had one child, Koos (1914–1986) (Conversation with Bill, Feb. 18, 1981; telephone conversations with Jos de Kooning, Aug. 12, 1999, and E. J. Lassooy, Aug. 17, 1999).

8. In 1974 artist Ray Johnson (1927–1995) asked Bill what his favorite childhood toy was; Bill replied, "a

cart." He then made a charcoal drawing of it and gave it to Ray. The drawing was reproduced in Johnson's article, "Abandoned Chickens" (*Art in America* 62, no. 6, Nov./Dec. 1974, p. 108).

9. Academie voor Beeldende Kunsten en Technische Wetenschappen (Academy of Fine Arts and Techniques).

10. Hess wrote that Bill remained at the Rotterdam Academy until 1924, at the age of twenty (Thomas B. Hess, *Willem de Kooning* [New York: George Braziller, 1959], p. 113). Elaine recalled that when they first met, Bill told her that he had studied at the academy in the evening until 1921 (at age seventeen), and attended sporadically during the following three years into 1924 (at age twenty). She added, "In all fairness, Bill's stories had occasional variations and Tom had to rely on what he told him at the time. Tom asked Bill to proofread his manuscripts before they were published, but Bill said he never got around to it" (Conversation, Jan. 28, 1983).

11. Leo Cohan (1896–1977) forged a peripatetic life in America, dabbling in real estate, dealing in antiques, and working as a waiter and bartender in upscale restaurants. He eventually married and settled in New Jersey. In September 1968, Bill invited Leo to travel with him to Holland for the opening of his retrospective at the Stedelijk Museum in Amsterdam ("Willem de Kooning," Sept. 19–Nov. 17). It was Bill's first trip to his native country since his voyage to America in 1926 (Conversation with Bill, June 7, 1985; Thomas B. Hess, *de Kooning* [New York: M. Knoedler & Co., 1969], p. 8).

12. In the 1940s, Nini (Virginia) Diaz (1904–1998) married Andrew Halusic. After his death she traveled around the United States and eventually retired to a trailer camp in southern Florida. Elaine visited her in the mid-1980s, and shortly after Elaine returned to East Hampton, Bill sent Nini a 1960s figurative painting, approximately forty by twenty-six inches in size. A few days later, Nini returned the painting and asked him to send her something smaller. "Thank you for the thought, Bill, but the one you sent won't fit in my trailer," she wrote (Conversation with Elaine, Sept. 29, 1986).

13. Bill met John D. Graham (Ivan Gratsianovitch Dombrovski, c. 1881–1961) in 1929, at the time of Graham's exhibition at the Dudensing Galleries (5 East Fifty-seventh Street; "John Graham Paintings," April 8–22, 1929) (Conversation with Bill, Oct. 12, 1979; *The Art News* 27, no. 27 [1929], p. 29). Graham's knowledge of the most modern thinking in European art was of considerable interest to the New York artists he befriended in the 1930s, and many of his ideas were expounded in *System and Dialectics of Art*, a treatise he published in 1937. The idiosyncratic book was catechistic in style, posing and answering such questions as "What is art?" "What is beauty?" "What is functionality?" and "What is the language of form?" Regarding "What is abstraction?" Graham wrote: "Abstraction is the evaluation of form perfectly understood. Objectively, abstracting is the transposition (transmutation) of the phenomenon observed into simpler, clearer, more evocative and organically final terms. Subjectively, abstracting is an

ability to evaluate events observed into a new and synthetic order" (Marcia Epstein Allentuck, ed., *John Graham's System and Dialectics in Art* [Baltimore: Johns Hopkins Press, 1971], p. 94).

"American and French Paintings" (Jan. 20–Feb. 6, 1942), was held at McMillen Inc., an interior design firm that exhibited art at 148 East Fifty-fifth Street; the exhibition was Bill's first showing in a gallery (*New York Times*, Jan. 18, 1942).

14. The *ARTnews* critic wrote, "But a tight-rope walker, Virginia Diaz, walks off with the show in a brace of thoughtful little canvases" (*ARTnews* 40, no. 19 [1942], p. 29).

Arshile Gorky (Vosdanig Manoog Adoian, 1904–1948) and Bill were introduced to each other by artist Mischa Reznikoff in the winter of 1930–31. "A few weeks after Gorky and Bill met," Elaine recalled, "they went uptown to see some shows. In one gallery, Bill expressed an opinion about a painting they were standing in front of. Gorky turned suddenly to Bill and said, "What do you know about it, my good man? You are only a commercial artist." Bill fired back, "Yeah, well I can punch you in the nose!" "You can't punch me in the nose," Gorky replied in a dismayed tone, "you're smaller than I." Months later Bill learned that Gorky had defended him in a discussion with other artists by saying, "Maybe he's a commercial artist, but de Kooning knows more about painting than any of you" (Conversation with Bill, Nov. 10, 1979; conversation with Elaine, June 26, 1987).

Jackson Pollock (1912–1956) and Lee (Lenore) Krasner (1911–1984) showed paintings that were derivative of Picasso but, according to Krasner, "loaded with American guts" (Conversation with Porter McCray, July 20, 1987).

About the evolution of his work, Stuart Davis (1892–1964) wrote, "The 'abstract' kick was on. The culmination of these efforts occurred in 1927–28, when I nailed an electric fan, a rubber glove and an eggbeater to a table and used it as my exclusive subject matter for a year. The pictures were known as the 'Egg Beater' series and aroused some interested comment in the press, even though they retained no recognizable reference to the optical appearance of their subject matter" (Stuart Davis, *Stuart Davis* [New York: American Artists Group, 1945], n.p.).

15. Juliet Browner (1911–1991) eventually traveled to California, where she met Man Ray (1890–1976) in the autumn of 1940. They were married on October 24, 1946 (Conversation with Juliet Man Ray, Paris, June 29, 1984; telephone conversation with Eric Browner, Aug. 14, 1999).

16. In the 1930s, Norman K. Winston (1899–1977) was an import-export trader and a prosperous real-estate speculator. After World War II, he became a major builder of middle-income housing in metropolitan areas throughout the United States (*New York Times*, Oct. 12, 1977).

17. In an attempt to capture the subtleties of atmosphere and light more directly, Eugène Boudin (1824–1898) became one of the first French artists to paint outdoors. He is credited with convincing Monet to abandon his studio for painting *en plein air*.

18. Born in Kiev, Vera Berlin (1912–1994) met John Graham through mutual Russian friends in New York; he introduced her to Bill in 1933. She married Richard Jessup, a prolific writer of novels and screenplays, and led an active life in the worlds of ballet and classical music (Conversation with Vera Jessup, Aug. 18, 1985; telephone conversation with Marina Jessup, Aug. 16, 1999).

19. Under the auspices of Franklin D. Roosevelt's New Deal, the WPA (Works Progress Administration, 1935–43) was responsible for the production of more than 2,500 murals, 18,000 pieces of sculpture, and hundreds of thousands of prints, paintings, and photographs throughout America.

20. In "Long Ago with Willem de Kooning" (*Art Journal* 48, no. 3 [Fall 1989], p. 222), the photographer Rudolph (Rudy) Burckhardt (1914–1999) stated that he lived next door to "Bill and Juliet" on Twenty-first Street in 1935. However, Elaine recalled Bill's saying that he was still living with Nini at the time of the encounter with the WPA representative in 1935. Juliet told me that she did not meet Bill until the summer of 1936 and that they eventually "lived together for a while in his loft on West Twenty-second Street" (Conversation with Elaine, Sept. 10, 1982; conversation with Juliet Man Ray, Paris, June 29, 1984).

21. Although Bill was originally assigned to the easel division, after a few months he transferred to the mural division of the WPA (Conversation with Bill, Nov. 24, 1979). Fernand Léger (1881–1955) was in the United States for his American retrospective "Fernand Léger: Paintings and Drawings" (Sept. 30–Oct. 24, 1935), which opened at the Museum of Modern Art and traveled to three subsequent venues. Only six of the artists assigned to the mural executed designs, and, as Mercedes Matter recalled, they "spent hours shivering in the winter cold, studying the pier and discussing ideas." In addition to Bill, Harry Bowden (1907–1965), Byron Browne (1907–1961), Balcomb Greene (1904–1990), Mercedes Matter (b. 1913), and George McNeil (1908–1995) collaborated. The mural was never executed, although several sketches have survived (Telephone conversation with George McNeil, May 28, 1987; conversation with Mercedes Matter, June 27, 1987).

22. Artist Burgoyne Diller (1906–1965) was head of the mural division of the WPA from 1935 to 1940. Under the Federal Art Project, he was involved in the planning of the 1939–40 New York World's Fair, and he secured Bill's commission to design a ninety-foot section of the Hall of Pharmacy's outdoor facade. Stuyvesant van Veen (1910–1988) and Michael Loew (1907–1985) designed the other two sections of the three-part mural (Conversation with Bill, Feb. 7, 1981; conversation with Michael Loew, Nov. 18, 1982).

23. Shortly after moving to 143 West Twenty-first Street, Bill met the poet Edwin (Orr) Denby (1903–1983) and Rudy Burckhardt, who were living next door, in the fifth-floor loft at 145 West Twenty-first Street. The twin buildings faced south and overlooked Twenty-first Street; they were identical in design, five stories high, and had fire escapes in the back

(Site inspection, May 22, 1998).

24. Max Margulis (1907–1996) met Bart van der Schelling while touring on the New York vaudeville circuit. In the 1930s Max played in speakeasies and performed with dance bands on luxury passenger ships (he made twenty-one transatlantic crossings). By the time he met Bill, Max was living at 300 West Twenty-third Street (Conversation with Bill and Elaine, Dec. 15, 1979; telephone conversation with Helen Margulis, Aug. 30, 1999).

25. In *Willem de Kooning Paintings* (Washington: National Gallery of Art, 1994, p. 83 n. 14), Marla Prather cited "Pitt" as the name of Ellen Auerbach's husband. His name was Walter; "Pit" was Ellen's nickname (Telephone conversations with Ellen Auerbach, May 3, 1982, and Aug. 13, 1999).

26. The blue glass decanter figured prominently in *Glazier* (c. 1940), though in a reddish tonality; it was in Elaine's possession at the time of her death.

27. Charles Fried (1886–1951) and Mary Ellen O'Brien (1888–1964) had four children: Elaine (1918–1989), Marjorie (1919–1998), Conrad (b. 1920), and Peter (1922–1995). Charles Fried was a plant manager for the General Baking Company in New York, and Mary Ellen (Marie) was a housewife; the family lived in Brooklyn. In 1936 and 1937, Elaine attended Hunter College Annex (145 East Thirty-second Street), the Leonardo Da Vinci Art School (149 East Thirty-fourth Street), where she met Conrad Marca-Relli, and the American Artists School (131 West Fourteenth Street), where she met Milton Resnick and Ernestine Blumberg (Lassaw) (Conversations

with Elaine, March 5, 1982, and Nov. 18, 1983; conversation with Ernestine Lassaw, May 29, 1999; telephone conversation with Conrad Fried, Aug. 2, 1999).

The Stewart's cafeteria where Elaine and Bill first met was located at 176 West Twenty-third Street, around the corner from Bill's loft.

28. According to Bill and Elaine, Nathaniel (Nat) Norman, an engineer at Bell Telephone Laboratories, was a friend of Max Margulis. In the mid-1930s, Nat had built a state-of-the-art phonograph for Max, and at Max's request, he fabricated a similar one for Bill (Conversation, Dec. 15, 1980; telephone conversation with Helen Margulis, Sept. 5, 1999). This conflicts with Sally Yard ("Willem de Kooning: The First Twenty-Six Years in New York," Ph.D. diss., Princeton University, 1980, p. 26), in which Norman is unnamed and referred to as "the Bell engineer"; he is cited as Bill's friend and credited with introducing Max to Bill.

29. The building at 156 West Twenty-second Street was four stories high. Bill's third-floor studio had plate-glass windows facing north, overlooking Twenty-second Street. At the opposite end of the loft, three average-sized windows faced south; one opened onto a fire escape. Sculptor Martin Craig lived in the second-floor loft (Conversation with Bill, Aug. 9, 1980; site inspection, May 22, 1998).

30. Bill and Elaine eventually acquired an original Krazy Kat cartoon, the black-and-white Sunday page for Nov. 12, 1922.

31. A year earlier, Denby had begun to write dance crit-

icism. From 1942 to 1945, he was a dance critic for the *New York Herald Tribune*, and he continued to publish essays and articles on the subject through the 1960s. "He taught three generations to see more than they had first suspected," Lincoln Kirstein observed, "and inspired more than one young English literature student to think with care about writing on dancing" ("On Edwin Denby," *Edwin Denby, The Complete Poems* [New York: Random House, 1986], p. 183).

32. Several chronologies have stated that Bill and Gorky shared a studio "for a number of years in the late 1930's." The earliest reference seems to have been Thomas B. Hess (1959, p. 114). When I brought this to Elaine's attention in 1984, she stated unequivocally that Bill and Gorky never shared a studio. She had asked Hess about this at the time his book was published, but he could not recall the source. Elaine surmised that he based the information on a letter Bill wrote to *ARTnews*, a few months after Gorky's death: "If the bookkeepers think it necessary continuously to make sure of where things and people come from, well, then, I come from 36 Union Square" (*ARTnews* 48, no. 9 (1949), p. 6). "36 Union Square" was the address of Gorky's studio; by giving it as his address, Bill was acknowledging Gorky's friendship and influence (Conversation with Elaine, May 14, 1984).

33. The drawings were published in the March 1, 1940, issue of *Harper's Bazaar*, p. 81.

34. "Through his knowledge and love of jazz, Max instilled an enthusiasm for the genre in many of his friends," Elaine recalled. "One night in the early fifties, Bill and I went out with some artists to a jazz club, where we lingered until late in the evening. Only a few people were left in the place, and the musicians were improvising in a hypnotic, dreamy mood. Through the smoky haze a soft voice began to sing—unmistakable! An inspired thrill suddenly entered the band's playing—a new watchful tension—as everyone looked at each other and froze. Billie Holiday, herself, stood there at the mike, whispering into it. We knew that she had been forbidden to sing (her cabaret license had been revoked), but she seemed to sense that there wasn't a person in the room—all strangers—whom she couldn't trust. It brought tears to everyone's eyes. Singing was the blood in her veins, and she responded to the hush in the air, the reverence of the musicians, the spellbound audience" (Conversation, Aug. 26, 1988).

Bill met Aaron Copland (1900–1990) through Edwin Denby, following the premiere of "The Second Hurricane," on April 21, 1937. Denby had written the opera's libretto and Copland composed the music; the first performance was directed by Orson Welles at the Henry Street Settlement in New York (Conversation with Edwin Denby, Nov. 8, 1981).

35. Welfare Island was renamed Roosevelt Island in the early 1970s, when the construction of a large residential community was planned for the island by the Urban Development Corporation of New York. Eight hundred feet wide, by one and three-quarters of a mile long, the island is situated in the East River between Fifty-first and Eighty-sixth Streets.

36. To date chronologies have credited Edwin Denby rather than Vera Berlin with securing this commission (*Willem de Kooning Drawings Painting Sculpture* [New York: Whitney Museum of American Art, 1983], p. 270; Judith Zilczer, *Willem de Kooning from the Hirshhorn Museum Collection* [New York: Rizzoli, 1993], p. 188; *Willem de Kooning* [Paris, Centre Georges Pompidou, 1984], p. 182, etc.).

37. This describes one of the sittings for Bill's *Portrait of Elaine*, c. 1940–41, pencil on paper, 12¼ x 11⅞", private collection.

38. In the late 1930s and 1940s, the cafeterias most frequented by artists were the Stewart's cafeteria at 176 West Twenty-third Street (on the corner of Seventh Avenue), the Stewart's at 35 Union Square (on the west side of the square opposite Gorky's 36 Union Square studio), and the Waldorf cafeteria at 394 Sixth Avenue (between Waverly Place and Eighth Street) (Conversation with Elaine, Feb. 10, 1986; conversation with Mercedes Matter, July 14, 1988).

39. For the entire year before she and Bill were married, Elaine worked at Liquidometer as a pantograph operator, incising numbers and letters on airplane dials. To balance the monotonous concentration required to fill her defense plant quotas, she read all seven volumes of *Remembrance of Things Past* in the subway to and from work.

40. Several chronologies have listed Bill's Fourth Avenue address as 88 Fourth Avenue (Whitney Museum of American Art, 1983, p. 271; Zilczer, 1993, p. 190, etc.). Grace Church was erected in 1846; in 1944, there was no "88 Fourth Avenue" because the church occupied that entire block. Today the church remains standing, and "85 Fourth Avenue" is across the street facing the back of it as Elaine described. The building in which Bill had a studio has been replaced.

41. Elaine considered her mother's reaction "droll and outlandish"; her father's response differed somewhat. "I'm getting married," Elaine told her father. "Bill," he said quietly, reading a newspaper. "On December ninth," she continued. "I hope you'll be there." "Sure," he replied (Conversation, Sept. 14, 1985).

42. Max Margulis is listed as best man in Whitney Museum of American Art (1983, p. 271); Bart van der Schelling is given the same designation in Zilczer (1993, p. 190). On the subject, Elaine remarked, "The term 'best man' implied a formality that was not part of the ceremony. Max arrived a few minutes late, prompting the justice to peer over his glasses and utter in a surly tone, 'And who's this?' to which Bill replied, 'Our best man, of course!'" (Conversation, Aug. 14, 1986).

43. Owing to the technical limitations of his audio equipment, Edgard Varèse (1883–1965) had not begun to use taped sounds in his music until the early 1950s. *Déserts* (c. 1950–54) was scored for instrumental music and two electronic tapes. In 1955 Varèse produced "La procession de la Vergès," an electronic soundtrack for a sequence in the film *Around and About Joan Miró*, directed by Thomas Bouchard. *Poème électronique* (1957–58) was an electronic tape composition.

44. Elaine described two wooden objects made by the sculptor Martin Craig that were on stage during the ballet: "One was painted pink, the other yellow, and the colors and biomorphic shapes interacted with forms in Bill's backdrop" (Conversation, Aug. 5, 1985). The only mention of Craig's contribution to the ballet appeared in a review of the performance: "The major work of the evening was 'Labyrinth' with a score by David Diamond and decor by Willem de Kooning and Martin Craig" (*New York Herald Tribune*, April 6, 1946).

45. In 1985 Milton (Rachmiel) Resnick (b. 1917) wrote: "Perhaps there is a greater thing in the power of things to display themselves in ways we cannot recognize. That all things have life and even emptiness—I go by that, explore that. Paint is as much a thing in life, precious and important to me. I wait upon it as servant rather than as master" ("Statement," *Milton Resnick, Paintings 1945–1985* [Houston: Contemporary Arts Museum, 1985], p. 73).

46. The aria, from Act II, Scene 3, begins with the words, "The revenge of hell boils in my heart."

47. The performance took place at the Hunter Playhouse, Hunter College, on May 12, 1946. Dancer/choreographer Merce Cunningham (b. 1919) presented several works that evening with music by John Cage (1912–1992): *Root of an Unfocus*, *Tossed As It Is Untroubled*, *The Encounter*, and *Totem Ancestor*.

In "The American Action Painters," critic Harold Rosenberg (1906–1978) wrote: "At a certain moment the canvas began to appear to one American painter after another as an arena in which to act— rather than as a space in which to reproduce, re-design, analyze or 'express' an object, actual or imagined. What was to go on the canvas was not a picture but an event. . . . Call this painting 'abstract' or 'Expressionistic' or 'Abstract-Expressionistic,' what counts is its special motive for extinguishing the object, which is not the same as in other abstract or Expressionistic phases of modern art" (*ARTnews* 51, no. 8 [Dec. 1952], pp. 22–23, 48–50).

John Cage eventually dedicated one of his *Seven Haiku* (1952, piano solo) to Bill, and a piano concerto to Elaine. One evening at a party in Manhattan, John confided to Elaine that he didn't have enough money to drive back home; it was 1958, and he was living in Stony Point, about an hour north of the city. Elaine opened her purse, found three dollars, and slipped them into John's hand. A few days later, on February 25, she mailed him a check for one hundred dollars with a note, "Dear John, I hereby commission you to write a piece of music. Love, Elaine." Later that year John presented Elaine with a copy of his *Concerto for Piano and Orchestra* (1957–58), which he had dedicated to her. She glanced through the unwieldy sixty-three-page score and said affectionately, "But John, I didn't expect such a portentous piece!" (Conversation with John Cage, July 20, 1981; Elaine and Willem de Kooning Financial Records, 1951–69, Archives of American Art, Smithsonian Institution, Washington, D.C.).

48. While writing her piece about Black Mountain College for *Vogue* ("de Kooning Memories: Starting Out in the 1940's, A Personal Account" [Dec. 1983], pp.

350–53, 393–94), Elaine recollected that she and Bill saw Gorky for the last time at a party coinciding with Gorky's exhibition at the Julien Levy Gallery (Feb. 29–March 20, 1948). In *Jackson Pollock: An American Saga* (New York: Harper Perennial, 1991, p. 559), the authors Naifeh and Smith placed this encounter at a party for Bill's April show at the Egan Gallery, citing Ethel Baziotes as the source. Ethel Baziotes told me that the incident occurred at a party for Gorky, not Bill, "making Pollock's behavior the more egregious." She added that Pollock arrived "drunk, belligerent, and voluble," and that her husband shouted "Shut up, Jack!" as Pollock approached Gorky (Telephone conversation, May 23, 1998).

49. Elaine had noticed that Gorky's wife, Agnes, was absent from the party; several years earlier, she had introduced them to each other. "During the winter holiday season," Elaine recalled, "either the very end of 1940, or the beginning of 1941, Bill and I were invited to a Sunday afternoon party at Fred Schrady's studio on Twenty-third Street. Agnes Magruder, a recent acquaintance of ours, also knew Fred and his girlfriend, Kay Mason, and she told us that she was going to the party. . . . One day Gorky dropped by Bill's studio and kept talking about how much he wanted to have a young girlfriend, 'like you have, Bill. They're so strong, these American girls,' he said in a repining tone. 'Well, at a party we are going to, there will be a girl who you would like very much,' I said, 'so why don't you come with us?' At first Gorky didn't want to, but I coaxed him, and he finally agreed. . . . At the party I noticed that Gorky kept hovering around Kay Mason. He was spending too much time with her, so I walked over and tugged at his coat sleeve, whispering and pointing surreptitiously, 'No, not this one, that one!' Then I took Gorky over to Agnes and introduced him to her. Shortly after the party, they were inseparable, and they married about six months later" (Conversation, Jan. 12, 1988).

50. Charles Egan (1911–1993) held one other de Kooning exhibition at his gallery, "Willem de Kooning," April 1–30, 1951.

51. At about the same time, George Keller of the Bignou Gallery, at 32 East Fifty-seventh Street, also approached Bill for a show (in 1943, the gallery had included Bill in its "Twentieth Century Painting" exhibition, Feb. 8–March 20).

Howard Putzel, who was Peggy Guggenheim's assistant from 1942 to 1944 at Art of This Century, opened his own 67 Gallery in 1944. In the spring of 1945, he expressed interest in a de Kooning exhibition, but he died a few months later, on August 7 (Conversation with Bill and Elaine, Aug. 9, 1980).

52. *Magazine of Art* reproduced *Painting*, 1947 (oil, 30 x 46"; purchased by Lee V. Eastman and renamed and redated *Bill-Lee's Delight*, 1946), and *Painting*, 1947 (oil, 24 x 30"). Elaine recalled that when photographs were submitted to *Magazine of Art*, neither of the paintings had been titled. The smaller painting was titled *Orestes* at her suggestion on the evening described in the previous anecdote (*Magazine of Art* [Feb. 1948], p. 54; conversation, Oct. 20, 1984).

ARTnews reproduced *Painting*, 1948 (enamel and

oil on canvas, 42⅝ x 56⅛"; purchased by the Museum of Modern Art). Decades later Bill considered the accompanying text by Renée Arb to be a prophetic statement about his work. In her brief piece Arb wrote, "Indeed, his subject seems to be the crucial intensity of the creative process itself, which de Kooning has translated into a new and purely pictorial idiom" ("Spotlight on: de Kooning," *ARTnews* 47, no. 2 [April 1948], p. 33; conversation, July 4, 1980).

Black Mountain College was founded in 1933 as an experimental liberal arts school. Situated on the shore of Lake Eden in Asheville, North Carolina, the unaccredited college attracted an auspicious faculty and was attended by approximately 1,200 students in its twenty-four-year history. It closed in 1957. From the year of the college's inception, artist Josef Albers (1888–1976) was instrumental in hiring the faculty. In 1950 he invited Bill to teach the fall semester at the School of Fine Arts, Yale University, New Haven, Connecticut.

53. When Bill and Elaine first met Ray Johnson, "he appeared at our cabin with soft yellow fuzz all over his head, like a baby chicken that had just hopped out of an egg" (Conversation with Elaine, May 14, 1984).

R. Buckminster Fuller (1895–1983) attempted the construction of his first large geodesic dome at Black Mountain College that summer. "The shape was to be a half-sphere, consisting of intersecting tetrahedrons of venetian blind slats," Elaine said. "But shortly after the work began, an unrelenting drizzle fell, and the dome never got off the ground—it collapsed like a pile of wet spaghetti. Bucky, however, was undaunted" (Conversation, March 12, 1988). "The most poetical experiences of my life," Fuller wrote, "have been those moments of conceptual comprehension of a few of the extraordinary generalized principles and their complex interactions which are apparently employed in the governance of universal evolution" (R. Buckminster Fuller, *No More Secondhand God and Other Writings* [Carbondale: Southern Illinois University Press, 1963], p. xii).

Among the films Arthur Penn (b. 1922) later directed were *Bonnie and Clyde* (1967), *Alice's Restaurant* (1969), and *Little Big Man* (1970).

At Black Mountain College in the summer of 1953, Cunningham formed the Merce Cunningham Dance Company; since then, he has created more than one hundred and fifty dances. His five-decade association with composer John Cage introduced such innovations as the independence of dance and music in collaborative works, the use of chance operations, and the incorporation of computers in evolving new choreography (Conversation with Merce Cunningham and John Cage, March 2, 1984).

54. These remarks supplement the article Elaine published about the 1948 summer at Black Mountain College (see note 48).

55. In the autumn of 1949, the Club was formed at a meeting in the Lassaws' loft at 487 Sixth Avenue (in 1936, the American Abstract Artists was organized in Ibram Lassaw's studio at 232 Wooster Street). The

Club was located at 39 East Eighth Street (Conversation with Alcopley, April 20, 1986; conversations with Ibram and Ernestine Lassaw, June 18, 1998, and Aug. 28, 1999; L. Alcopley, "The Club," *Issue, A Journal for Artists* 4 [1985], pp. 45–47).

From 1982 to 1988, in discussions I had with Elaine and Bill, Alcopley, Philip Pavia, Ernestine and Ibram Lassaw, Georgio Cavallon, Mercedes Matter, Joop Sanders, and Milton Resnick, there seemed to be no consensus regarding the number of "founding members," "charter members," and "voting members." Also, the accuracy of lists purportedly from the period was disputed by several of the surviving members. Numbers ranged from ten to twelve "founding members" (Alcopley, Georgio Cavallon, Bill de Kooning, Franz Kline, Ibram Lassaw, Landis Lewitin, Conrad Marca-Relli, Philip Pavia, Milton Resnick, Jan Roelants, James Rosati, and Joop Sanders) to some twenty "charter members," and more than one hundred "voting members."

At the Club on April 12, 1950, Max Margulis gave a lecture entitled "Mozart," during which he played dozens of musical excerpts from his record collection and interspersed them with biographical details and technical insights (Conversation with Elaine and Bill, May 19, 1984). John Cage gave his "Lecture on Something" at the Club on February 9, 1951. It began: "This is a talk about something and naturally also a talk about nothing. About how something and nothing are not opposed to each other but need each other to keep on going" (John Cage,

Silence [Middletown, Conn.: Wesleyan University Press, 1961], pp.128–45).

56. Painter Roy Newell (b. 1914) was evolving his richly hued geometric style at the time. Joop Sanders (b. 1921) was painting tightly composed portraits and figurative works.

57. When he met Bill in the early 1930s, Ibram Lassaw (b. 1913) had already begun to create open-space abstract sculpture; he had finished the first piece in 1933. "My interest in a 'sculpture of relativity' reflects for me what I consider as the universe of relativity," he wrote. "The reality I see before me is living organism and, I believe, all its parts are ultimately in ecological interdependence. I as a man and an artist participate in it according to my nature, just as a carbon atom in one of my body cells participates in my being" ("Perspectives and Reflections of a Sculptor: A Memoir," *Leonardo* [Oxford: Pergamon Press, 1968], I no. 4, pp. 351–61).

58. At this time, sculptor Giorgio Spaventa (1918–1978) was producing small figurative works in wax and plaster, cast in bronze.

Bill commented that throughout history the crucified body "often looked like the letter 't'" (Conversation, May 27, 1985).

59. Franz Kline (1910–1962) was living and painting at 52 East Ninth Street.

60. In "Notes on Painting," William Baziotes (1912–1963) wrote: "Plasticity! How well the great Mondrian understood that. Plasticity! What does it mean? It means that one can take Rembrandt's *Old Man With a Beard*, hang it upside down, walk a hundred

yards away, look—and be enchanted by its abstraction" ("Notes on Painting," *It is.*, no. 4 [1959], p. 11).

61. This was Barnett Newman's (1905–1970) first solo exhibition ("Barnett Newman," Betty Parsons Gallery, New York, Jan. 23–Feb. 11, 1950). Three years earlier he had written: "The basis of an aesthetic act is the pure idea. But the pure idea is, of necessity, an aesthetic act. Here then is the epistemological paradox that is the artist's problem" ("Introduction," *The Ideographic Picture* [New York: Betty Parsons Gallery, 1947], n.p.).

62. In one of his essays, scholar Meyer Schapiro (1904–1996) reflected, "Both concepts of unity—the perfect correspondence of separable forms and meanings and the concept of their indistinguishability—rest on an ideal of perception which may be compared with a mystic's experience of the oneness of the world or god, a feeling of the pervasiveness of a single spiritual note or of an absolute consistency in diverse things. I do not believe that this attitude, with its sincere conviction of value, is favorable to the fullest experience of a work of art. It characterizes a moment or aspect, not the work as disclosed through attentive contemplation, which may also terminate in ecstasy" ("On Perfection, Coherence, and Unity of Form and Content," *Theory and Philosophy of Art: Style, Artist, and Society* [New York: George Braziller, 1994], p. 48).

As the first director of the Museum of Modern Art, in 1929, Alfred H. Barr, Jr. (1902–1981) coined the phrase "abstract expressionism" to describe paintings by Wassily Kandinsky; within twenty years the term was freely applied to members of the New York School. Barr selected Bill to be one of six artists who represented the United States in 1950 at the XXVth Venice Biennale (Conversation with Porter McCray, Jan. 30, 1991).

Holger Cahill (1887–1960) was the national director of the Federal Art Project under the WPA. In that capacity, he included Bill in "New Horizons in American Art," an exhibition of WPA art held at the Museum of Modern Art; it was Bill's first showing in a museum. His work was listed in the catalogue as part of the Williamsburg Federal Housing Project: "Series of proposed murals by group of eleven New York artists for social rooms of each housing unit: #65, William [*sic*] de Kooning, *Abstraction: color study for panel in oil on canvas*") (*New Horizons in American Art* [New York: The Museum of Modern Art, 1936], p. 144).

Gorky introduced sculptor Isamu Noguchi (1904–1988) to Bill in the mid-1930s (Conversation with Bill, June 7, 1980).

Thomas B. Hess (1920–1978) was assistant editor of *ARTnews* from 1946 to 1965 and the editor from 1965 to 1972; he was the author of more than a dozen monographs, exhibition catalogues, and articles on Bill (Conversation with Elizabeth Wolff, Oct. 16, 1996). "De Kooning's art is one of antinomes," Hess wrote, "of mutually exclusive contradictions, of theses and antitheses kept in tension, without the resolution of synthesis, of harmony or balance" (Thomas B. Hess, *Willem de Kooning Drawings* [Lausanne: Editions des Massons, 1972], p. 56).

In reviewing Bill's first show, critic Clement Greenberg (1909–1994) wrote: "There is a deliberate renunciation of will in so far as it makes itself felt as skill, and there is also a refusal to work with ideas that are too clear. But at the same time this demands a considerable exertion of the will in a different context, and a heightening of consciousness so that the artist will know when he is being truly spontaneous and when he is working only mechanically. Of course, the same problem comes up for every painter, but I have never seen it exposed as clearly as in De Kooning's case" (*The Nation*, April 24, 1948, p. 448).

The names of those who recommended Bill were verified in a letter of March 9, 1999, from the John Simon Guggenheim Memorial Foundation.

63. Sculptor Philip G. Pavia (b. 1912) was the chief organizer of the Club, for which he raised money, paid bills, acted as treasurer, and coordinated meetings, panels, lectures, and parties. He was the editor of *It is.*, in which he wrote, "The abstract artist completes his problem like a dialectical movement (as Aristotle would say) 'into a particularized stop.' He fits the light and space into every nook and cranny and articulates them like a living entity. In the final painting or sculpture, with total loss of the early kinship of problem-and-object drawing, he makes and fixes in one place a concrete measure that is absolutely unlike any other created thing" ("The Problem as the Subject Matter," *It is.*, no. 1 [Spring 1958], p. 2).

Artist Joan Ward (b. 1927), the mother of Bill's only child, Lisa, was integral to Bill's life from the 1950s until his death.

Nancy Ward (Martin) (1927–1973), the twin sister of Joan Ward, was Franz Kline's companion in the early to mid-1950s (Conversation with Elaine, May 14, 1982).

Elaine remarked that in his memoir about New York, Lionel Abel (b. 1910) gave an inaccurate account of the evening. Abel wrote, "They ate Henzler's [*sic*] roast lamb, poured his Moselle wine on the floor, drank his scotch and bourbon, broke his crockery, made love in the bedrooms, and left at four in the morning. Elaine de Kooning, in fact, walked with one leg in a cast all the way back to New York, leaving Henzler's dining room, and his whole house, like a disaster area." The Henslers' farm was about fifty miles from New York City (Lionel Abel, *The Intellectual Follies: A Memoir of the Literary Venture in New York and Paris* [New York: W. W. Norton, 1984], pp. 215–16; conversations with Elaine, Nov. 11, 1983, and July 19, 1985; conversation with Mercedes Matter, July 27, 1994).

On June 22, 1950, William Barrett (1913–1992) delivered a lecture at the Club entitled "Existentialism"; his seminal book on the subject was published eight years later (*Irrational Man* [New York: Doubleday, 1958]).

In the 1950s, Conrad Marca-Relli (b. 1913) evolved his personal style of collage, typified by canvas cutouts attached to a canvas support with opaque black glue; the glue lines demarcated and redefined the shapes in a network of tightly interlocked forms.

Of her work, Mercedes Matter remarked: "What

I want is depth compressed to the surface, and light emanating from the interaction of colors, not depicted. I want determinations of form through distinctions of pure color rather than value; I want energy through the plasticity of relations and I want the mysterious effect of transformation which results from finding the order of correspondence that is true to my perceived experience" ("Statement by Mercedes Matter," *Mercedes Matter, Paintings* [New York: Salander-O'Reilly Galleries, 1996], n.p.).

"Painting seems like an impossibility," Philip Guston (1913–1980) wrote, "with only a sign now and then of its own light. Which must be because of the narrow passage from diagramming to that other state—a corporeality. In this sense, to paint is a possessing rather than a picturing" (*12 Americans* [New York: The Museum of Modern Art, 1956], p. 36).

In 1958 the painter Raymond (Ray) Parker (1922–1990) observed, "To intend to control content implies controlling viewers' responses. But every response to painting is partly pre-conditioned, reflecting the viewers' associations in meaning which range from individual psychological quirks to what the humanist would think of as the traditions of culture. The intent painter does not pretend to reorganize all this, he simply deprives the viewer of it" ("Intent Painting," *It is.*, no. 2 [Autumn, 1952], p. 8).

64. Samuel M. Kootz (1898–1982) had included Bill's work in two group exhibitions at his gallery: "The Intrasubjectives," Sept. 14–Oct. 3, 1949, and "Black or White: Paintings by European and American Artists," Feb. 28–March 20, 1950.

65. The Cedar Street Tavern opened in 1933 at 55 West Eighth Street, and moved to 24 University Place (between Eighth and Ninth Streets) in 1945. In the late 1940s and the 1950s, artists referred to it as the "Cedar Tavern," "Cedar Bar," or the "Cedar." It was closed in the winter of 1962 and reopened in 1964 as the Cedar Tavern at 82 University Place (between Eleventh and Twelfth Streets).

66. By 1959 Joan Mitchell (1926–1992) had moved to Paris. She settled permanently in Vétheuil in 1968.

67. Bill and Elaine were occasional weekend guests at the Castelli home in East Hampton during the summers of 1950 through 1952. In 1953, Leo Castelli (1907–1999) and his wife, Ileana, invited Bill and Elaine to spend the entire summer with them, and they stayed for nearly two months. The other house guests were John Graham, Ileana's mother (who was married to Graham), Leo's teenage daughter, Nina, a school friend of hers, and Michel Sonnabend. "Bicycles and cars grew on trees," Elaine noted, "and in one afternoon Bill and I developed a keen interest in cycling, which he maintained into the 1970s." Bill never learned how to drive a car (Conversation with Bill and Elaine, April 17, 1982; conversation with Leo Castelli, March 31, 1988).

68. John Bernard Myers (John Joseph Myers, 1915–1987) was the director of the Tibor de Nagy Gallery, New York, from 1951 through 1970, a managing editor of *View*, and the author of *Tracking the Marvelous*, an art-world memoir (Telephone conversations with James Myers and Dolores Kaltenbach, Aug. 17, 1999).

The poets were Kenneth Koch (b. 1925), James Schuyler (1923–1991), and Frank O'Hara (1926–1966).

69. In the early 1950s, Mary Clyde (Abbott) (b. 1921) was painting hybrid abstractions composed of lyrical, collaged elements and resonant, open spaces.

70. Artist and teacher Hans Hofmann (1880–1966) observed: "Talent is, in general, common—original talent is rare. A teacher can only accompany a talent over a certain period of time—he can never make one. As a teacher, I approach my students purely with the human desire to free them from all scholarly inhibitions, and I tell them, 'Painters must speak through paint—not through words'" ("Statement," *It Is.*, no. 3 [Winter-Spring 1959], p. 10).

71. Ludwig (Lutz) Sander (1906–1975) evolved into a painter of open-grid abstractions in dour tones.

72. On November 4, 1981, Elaine provided additional details about the studio arrangements at the red house, expanding the description in Judith Wolfe, *Willem de Kooning Works from 1951–1981* (East Hampton: Guild Hall, 1981), p. 11.

73. "Schlemoozle" was Kline's pronunciation of *schlimazel*.

74. Carol and Donald Braider, who owned the House of Books and Music in East Hampton, had moved much of their inventory to the basement of the red house while their store was being renovated. In return for the temporary storage space, they loaned the summer tenants a black-and-white television and several pieces of furniture.

75. This amplifies previously published accounts of the story (B. H. Friedman, *Jackson Pollock: Energy Made Visible* [New York: Da Capo Press, 1995], p. 209; Jeffrey Potter, *To a Violent Grave: An Oral Biography of Jackson Pollock* [Wainscott: Pushcart Press, 1987], p. 201; Naifeh and Smith, 1991, p. 736, etc.) (Conversation with Bill and Elaine, April 29, 1982; conversation with Elaine, Aug. 14, 1987).

76. In *Willem de Kooning* (New York: Abbeville Press, 1983, p. 55), Harry Gaugh cited Edna as the hurricane, but Edna didn't hit Long Island until September 11, two weeks after Carol.

Everyone stayed at the house through the end of September, making occasional day trips to New York City. Ernestine Lassaw's diary noted that she and Ibram visited the red house on September 18 and played croquet with everyone (Conversation, May 8, 1998). At the end of September, Oma moved in with Elaine's sister, Marjorie, and her husband, Edmond Luyckx, who had an apartment in New York City not far from Elaine and Bill. Oma stayed with them until January and then returned to Holland.

77. Newman mistook "tin" for Bill's Dutch-accented pronunciation of the word "thin."

78. Lisa de Kooning, the daughter of Bill and Joan Ward, was born on January 29, 1956.

79. *Lisbeth's Painting*, 1958 (oil on canvas, 49½ by 63", Virginia Museum of Fine Arts).

80. This is a reference to the jagged-edged images of Clyfford Still (1904–1980), which he had begun to paint in 1947.

81. Wilfrid Zogbaum (1915–1965) had exhibited paintings in the first American Abstract Artists show in

1937; he eventually turned to abstract sculpture and excelled in contrasting welded metals with stone.

82. De Kooning chronologies have listed conflicting dates for Bill's purchases of land in East Hampton and the inception of his studio designs (Thomas B. Hess, *de Kooning: Recent Paintings* [New York: Walker and Company, 1967], p. 9; Diane Waldman, *Willem de Kooning in East Hampton* [New York: The Solomon R. Guggenheim Museum, 1978], p. 135; *Willem de Kooning Paintings*, 1994, p. 173, etc.). Bill bought the original 4.79 acre parcel on June 20, 1959, but didn't apply for a building permit until March 16, 1962. A certificate of occupancy was issued for the studio in May 1965. He bought two more parcels of land on February 23 and October 10, 1966, adding 6.1 acres to the original parcel (East Hampton Town Hall records, March 5, 1998; Suffolk County Real Property Tax Service Agency and Riverhead County Clerk's Office, March 9 and 10, 1998).

83. In *Willem de Kooning Paintings* (1994, p. 173), Prather stated that Bill did not hire an architect. According to Bill, in order to draw up plans for engineers and contractors, he consulted with and used the services of the architectural firm Juster & Gugliotta, at 366 Broadway in New York (Conversation, Feb. 17, 1981).

In the same paragraph the studio ceiling height was listed as thirty feet; it is nineteen feet, eleven inches, at the highest point, sloping to sixteen feet, seven inches, at the center of the studio.

Paul Gugliotta at Juster & Gugliotta designed the studio according to Bill's specifications, and his firm oversaw the framing. E. L. Mobley, a contractor, handled the construction; Otto Winkler, an architectural supervisor, insured that the structure was built according to the plans; and Alan H. Marks, a mechanical engineer, directed the electric, plumbing, and heating installations. On several occasions, Gugliotta had lengthy discussions with Bill about the use of pre-fab Pruden frame trusses to support the studio; Gugliotta thought them ugly, but Bill liked the look of them, and he prevailed. However, regarding the odd-angled exterior walls, Gugliotta convinced Bill to modify his original ideas. Bill wanted angles that varied $2\frac{1}{2}°$ on either side of the 90° wall intersections; Gugliotta advised him to vary the angles by a minimum of 5°, as smaller angles would be indetectable. The corners of the easel walls in the studio were subsequently built at 85° and 95°, respectively; other angles were chosen for the walls in the living area (Telephone conversation with Paul Gugliotta, July 26, 1999).

84. Diagrams of de Kooning's studio are on the following two pages.

First floor

1. Front entrance
2. Dining area
3. Kitchen area
4. Bathroom
5. Fireplace
6. Sitting area
7. Open area to second-floor balcony
8. Staircases from studio and living area to second floor
9. Studio

Second floor

1. Bill's bedroom
2. Door to second-floor front deck
3. Bedroom overlooking studio
4. Bathroom
5. Bedroom
6. Bathroom with walls open to ceiling
7. Bedroom
8. Bedroom overlooking studio
9. Sitting area
10. Balcony
11. Door "to nowhere"
12. Staircases to first floor and studio
13. Prow
14. Studio

85. Each step of the indoor staircases was a solid maple plank, one and three-quarter inches thick. The steps were "polished to a boat finish," complementing the benches, shelving, and other unpainted wood in the studio (Conversation with Bill, Dec. 14, 1984).

86. The dimensions of the dining table were ten feet by three and one-half feet.

87. The height of the upstairs bathroom walls was seventy-four and one-half inches, sloping to seventy-four inches.

88. Painter Herman Cherry (1909–1992) wrote about this relationship of the walls in his New York studio to the walls in Bill's East Hampton studio: "The third was an idea he [Bill] had gotten from my studio on Cooper Square, where no room was at right angles, owing to Fourth and Third Avenues' intersecting at that point" ("Willem de Kooning," *Art Journal* [1982], p. 230).

89. The terra-cotta tiles on both floors of the living area were six inches square.

90. The terrazzo floor was divided into rectangles twenty-one inches by twenty-four inches, with variations along the side walls of the studio. Regarding the cost of the terrazzo, Bill remarked, "If I had glued down twenty-dollar bills from end to end on the studio floor, it would have been cheaper" (Conversation, March 8, 1985).

91. The construction of a screened gazebo for the pool in the backyard was completed.

92. As a safety precaution, metal horizontal bars were installed across the door opening.

93. In *de Kooning* by Harold Rosenberg (New York: Harry N. Abrams, 1974), the two studio photographs on page 21 were horizontally reversed.

In *de Kooning: dipinti, disegni, sculture* (Milan: Studio Marconi, 1985), the lower studio photograph on page 13 and the two photographs on page 14 were horizontally reversed.

94. Bill's dealer at the time, Xavier Fourcade (1926–1987), had organized the trip to Japan and the excursions to Tokyo, Ise, and Kyoto. During his visit to a sumi-e workshop, Bill was struck by the brush technique of the artists and intrigued by their use of Japanese rice papers. Those impressions were with him, he recalled, when he began a series of lithographs the following year; from June 1970 to June 1971, he executed twenty-four lithographs, published by Hollander's Workshop in New York. Several of the editions were printed on Suzuki and Akawara papers; *Reflections: To Kermit for Our Trip to Japan, Wah Kee Spare Ribs, Love to Wakako,* and *Japanese Village* were among the titles. Eighteen of the prints were drawn on transfer paper and hand-printed from aluminum plates, two were drawn directly on aluminum plates, and four were drawn directly on stone (Conversation with Bill, April 11, 1981; conversation with Xavier Fourcade, Dec. 10, 1983).

95. Sculptor Herzl Emanuel (b. 1914) stated that all thirteen of Bill's original clay sculptures were destroyed at his foundry in Italy: "Two or three gelatin molds were fabricated from each clay sculpture, and each mold produced two or three bronze casts. The molds cracked during the castings, and the surviving clay

works were destroyed after the editions were completed." Because Bill returned to America before the castings, he authorized Herzl Emanuel to sign and number the untitled sculptures (Telephone conversation with Herzl Emanuel, Sept. 18, 1988).

96. *Clamdigger*, 1972, was the largest of Bill's sculptures in an original size, standing approximately five feet tall. It was one of eleven sculptures he made between 1972 and 1974, cast at the Modern Art Foundry in Queens, New York (in 1969, one of the small bronzes from Italy was enlarged to a medium size by that foundry). In the 1980s, three of the small bronzes from Italy were enlarged to a medium size, and again to a monumental size, at the Tallix Foundry in Peeksill, New York (Conversations with Bill, Aug. 7, 1981, and Jan. 20, 1986; *Willem de Kooning, Skulpturen* [Köln: Josef-Haubrich-Kunsthalle, 1983], figs. 1–27).

97. On September 23, 1975, after a twenty-year informal separation from Bill, Elaine purchased a house in the Northwest Woods area of East Hampton, about five miles from Bill's studio in the Springs section. The house, located at 45 Alewive Brook Road, was soon expanded into her studio, and during the spring of 1978, Elaine and Bill were reunited.

98. In "At Last Light" (*Willem de Kooning: The Late Paintings, The 1980s* [San Francisco: San Francisco Museum of Modern Art, 1995], p. 47), Robert Storr wrote: "Indeed, by 1980 he had virtually abandoned the practice of drawing, as the very few works on paper that can be positively ascribed to the decade attest." As a frequent visitor to the studio during that period, I observed Bill drawing with charcoal on note paper through 1980 and 1981, into the spring of 1982. During that period he variably produced one to four drawings a week. By the summer of 1982, he had stopped drawing on paper, although he continued to incorporate charcoal drawing into the early stages of his paintings on canvas.

99. Marisol Escobar (b. 1930) met Bill in the late 1950s. Her figurative sculptures are a droll interplay of two-dimensional renderings and three-dimensional wood carving, heightened with relief, trompe l'oeil, and multimedia materials.

100. One of the few published anecdotes from the 1980s appeared in Hayden Herrera's "Willem de Kooning: A Space Odyssey" (*Harper's Bazaar* [April 1994], p. 195; cited in Sally Yard, *Willem de Kooning* [New York: Rizzoli, 1997], p. 117). In her article, Ms. Herrera described Bill's spending an evening with Max Margulis but not recognizing him until he began to draw: "After a rather awkward dinner, de Kooning picked up a pencil and began to draw his friend. A few moments later he looked up and said, 'Oh, Max! It's you!' His hand, drawing form, had found the memory." On the evening cited, only Bill, Elaine, Max, his wife, Helen, and I were present, and none of us was a source for the story.

Although Max died on December 18, 1996, I subsequently verified the following with Helen Margulis. On a summer evening in 1983, Max and Helen arrived at Bill's studio for dinner. The conversation was animated and poignant, highlighted by Max's witty memories of jazz clubs, artists, openings, and

exhibitions. "Max had a way of telling twenty-minute jokes," Elaine remarked, "with each sentence hilarious, like a punch line. But when the punch line came, it was flat, which made the whole joke even more hilarious." After dessert Max set up his stereo viewer and showed 3-D slides he had taken in the thirties and forties in New York. When Bill saw the shot of Max standing next to his portrait of him, he looked up and said, "Max, it's you!" Everyone laughed. Although they had kept in touch by telephone, they had not seen each other for nearly thirty years, and the photograph was how Bill remembered Max. On that evening, Bill did not draw or paint (Telephone conversation, June 1, 1998).

101. In *Willem de Kooning Paintings* (1994, p. 202, n. 7), Prather wrote: "Such elaborate titles would become the exception in de Kooning's late work, since by 1975 he began to call most paintings 'Untitled' followed by a roman numeral." The "Untitled-roman numeral" designation was not initiated by Bill. At the suggestion of Xavier Fourcade, "Untitled" was adopted for cataloguing purposes in the mid-1970s, although the numbers did not represent the exact order of completion (Conversation with Xavier Fourcade, Sept. 14, 1985). Through the 1980s, paintings in the studio were not consistently numbered or photographed in chronological order.

ILLUSTRATED WORKS OF ART

all supported by industrial-grade casters.

64 *Untitled III*, 1984 (l.); *Untitled VI*, 1984 (r.)

65 *Untitled III*, 1984 (l.); *Untitled VIII*, 1984 (l.c.); <no title>, 1984 (r.c.); *Untitled IX*, 1984 (r.)

66 *Untitled X*, 1984 (l.); *Untitled XXI*, 1984 (r.). Bill often kept jars of medium on his painting table. Although he premixed a basic formula of approximately four parts stand oil, one part cold-pressed linseed oil, and five parts turpentine, he invariably added thinners or oils during the course of painting.

70 *Untitled II*, 1984. In 1985 Bill retitled this painting *Sleeping Figure* (see anecdote, p. 51); it retains the original *Untitled II* designation. The painting also appears on the jacket of this book.

71 *Untitled XVII*, 1984 (u.l.); *Untitled XXII*, 1984 (u.r.); *Untitled XX*, 1984 (l.l.); *Untitled XXI*, 1984 (l.r.)

73 <no title>, 1984 (l.); *Untitled XV*, 1984 (c.); *Untitled XX*, 1984 (r.)

74 *Clamdigger*, 1972. Upon coming indoors during the winter months, Bill occasionally threw his coat around *Clamdigger* or *Seated Woman on a Bench*, giving the sculptures an amusing, human presence.

76 *Untitled II*, 1984 (l.); *Untitled V*, 1984 (l.r.)

77 *Untitled V*, 1984 (l.r.)

78–81, 83 <no title>, 1985

84–90 <no title> paintings, 1987

91 *Standing Figure*, 1969–83

92 <no title> paintings, 1987 (u.c., l.r.); *Seated Woman on a Bench*, 1972 (c.). The (u.c.) photograph is a view of the studio from the second-floor landing; (l.r.) shows the prow. The (c.) view is from the opposite side of the landing to the living area below, with the sculpture at the foot of the staircase.

93–97 <no title> paintings, 1988

98–105 <no title>, 1989 (easel); <no title> paintings, 1988

106–13 <no title> paintings, 1988

ACKNOWLEDGMENTS

I am deeply grateful to Lisa de Kooning for her gracious cooperation and trust, and to John L. Eastman for his unstinting enthusiasm.

At Harry N. Abrams, Inc., Paul Gottlieb responded with immediate interest to the idea of this book, and he was vital to its realization. I am also indebted to my editor, Barbara Burn, for her incisive comments and generous advice, to Ray Hooper for his painstaking attention to the design, and to Hope Koturo for her astute production skills.

Ernestine and Ibram Lassaw, Mercedes Matter, and Hedda Sterne freely shared their recollections and insights, and they were a crucial source of inspiration.

I wish to thank to Dore Ashton, Jodie Eastman, and Abby Kreh for their friendship and encouragement, and the Foundation for Contemporary Performance Arts for its support in the preparation of photographs.